the art of
ENHANCED PHOTOGRAPHY

the art of
ENHANCED PHOTOGRAPHY

Beyond the Photographic Image

James Luciana • Judith Watts

MITCHELL BEAZLEY

First published in Great Britain by
Mitchell Beazley, an imprint of Octopus Publishing Group Ltd
Michelin House, 81 Fulham Road
London SW3 6RB

ISBN 1 84000 195 X

First published in the United States of America by
Quarry Books, an imprint of
Rockport Publishers, Inc.
33 Commercial Street
Gloucester, Massachusetts 01930-5089
Telephone: (978) 282-9590
Fax: (978) 283-2742

Design: Wren Design, Philadelphia, PA

Front Cover Images: *(top to bottom)* *Window: Jaipur, India* by Francois Deschamps,
Still life with Soap Bubble by Olivia Parker, *Untitled* by Jerry Uelsmann
Back Cover Image: *Finger Shadows* by Ernestine Ruben
Interior photo credits as follows:
Luiz Guimarães Monforte, pages 26–27: Photos of artist in studio by Joao Caldas
Thomas Mezzanotte, pages 32–33: Photos of artist in studio by Kvon
Francois Deschamps, pages 40-41: Photos of artist in studio by J. Mohns.
Judy Natal, pages 78–83: Photos of artist in studio by Susan Coolen; photos of artwork by Tom Nowak
Olivia Parker, pages 98–103: Photos of artist in studio by John Parker; artwork appears courtesy of Robert Klein Gallery

Printed in China.

ACKNOWLEDGMENTS

First and foremost, the authors would like to thank the creative artists included in this book. They were all extremely supportive and generous in supplying images, interviews and especially inspiration. In addition, we would like to thank the many fine artists who sent images for consideration. There was simply not enough room to include all the work we had to choose from, and many examples of quality work were left unpublished. Writing this book has been an extremely rewarding experience, and we thank our creative team at Rockport Publishers, especially Shawna Mullen, Martha Wetherill, and Lynne Havighurst, whose enthusiasm and support never wavered, and David Cottingham, whose sensitive and judicious editing was greatly appreciated.

Last, we would like to thank our families and colleagues, who always had time to listen to a passage or look at images. Sharing this work has been both inspirational and truly rewarding for us.

CONTENTS

FOREWORD

by A. D. Coleman

Recently, a young woman sent me a letter in which she wrote, "I believe that I am one of a very few photographers working with combined nineteenth-century processes." I didn't have the heart to break the news to her that, instead, she'd joined the ranks of an international movement that goes back some thirty years.

As that implies, we habitually date the start of the "alternative processes" tendency to the late 1960s and the spread of historical craft-related information resulting from the sudden growth of the formal photo-education system in the U.S. and elsewhere. In actual fact, however, all the different methods of light-sensitive and/or lens-derived image-making have always existed as alternatives to each other. Photography, from its birth onward, functioned as a seedbed of technical invention and subsequent experimentation with the possible permutations.

The medium's history, after all, commences with the contest between Daguerre's one-of-a-kind positives on silvered metal plates and Fox Talbot's salted-paper negatives and multiple paper positives. From there, we spill ceaselessly into new physical forms, and the imagistic potentials and presentational options they enable: cyanotype, tintype, ambrotype, wet plate, dry plate, albumen print, sheet film, roll film, lantern slide, stereo card and slide, platinum-palladium, gum bichromate, bromoil, Autochrome, Fresson print, Carbro process, silver-gelatin print, Kodachrome, dye transfer, Polaroid, hologram, digital image; collaged, montaged, assemblaged, photogrammed, multiply exposed, toned, solarized, hand-colored, chemically manipulated, silk-screened, reproduced in ink, hung on walls, bound in books, incorporated into installations, slide-projected, printed on a wide assortment of commercially produced and/or hand-sensitized papers, transferred to fabrics, embedded in ceramic, variously three-dimensionalized, even replicated in chocolate.

There are now so many engaged with all these historic and new hybrid forms, here and abroad, that no one book could encompass that entire territory. *The Art of Enhanced Photography* introduces you to a representative selection of those approaches, and to a cross-section of the visual artists who've revitalized and/or devoted themselves to their practice, ranging from those who rediscovered older processes and introduced them into the vocabulary of contemporary practice (Jerry Uelsmann, Bea Nettles) to those who work with the latest electronic methods (Olivia Parker, Joyce Neimanas),

and from those who invent unique new physical forms for the photographic image (Ernestine Ruben, François Deschamps) to those who push the envelope of how it can be presented (Rachel Murray, Keiichi Tahara).

As this project makes clear, any informed overview of the evolution of the photograph as an object and image involves the recognition that those who work creatively with photographs—photographers, artists from other media, and the population at large—have generated an enormous range of works that must be considered in any serious discussion of what constitutes the *photographic*. It also becomes obvious that the perception of creative photography from 1940 to 1970 as comprising a single type of artifact—the "straight" or unmanipulated black and white silver-gelatin print from an unmanipulated silver-gelatin negative encoding a single exposure, presented as an autonomous framed and matted artifact under glass, normally no larger than 20 by 24 inches (51 by 61 centimeters)—was, no matter how widespread, fundamentally erroneous. In hindsight, that narrow definition must be understood as the result not of the field's voluntary self-delimitations or of anything inherent to the medium but rather of the extreme biases of a small but briefly influential coterie of historians, curators, and photographers at a particular historical moment.

Happily, many picture-makers, here and abroad, refused all along to accept those strictures; and, starting in the 1960s, they—and a new, more broadminded generation of critics and historians—began the battle to restore to respectability all those other approaches. That fight is long over, the forces of tolerance have won, and those times are past. We live today in the context of what I call an "open photography," whose hallmarks include the remarkable fact that the entire creative toolkit of the medium—comprising virtually all of its tools, materials, processes, and styles, from the very beginning through the immediate present—has been recuperated and is available as a matter of course to the contemporary practitioner, without prejudice from the medium's critical/historical/curatorial establishment, and certainly without resistance from the market for photographic works. Notably, most of those nineteenth-century variations, no matter how arcane or tedious, are currently in use; the present generation of photographers includes practicing daguerreotypists, tintypists, cyanotypists, wet-plate collodionists, albumen and platinum printers—along with working holographers and digital-imaging devotees, who can be thought of as their direct or lineal descendants.

The field as a whole, unquestionably, has been reinvigorated by the recuperation of the fullness of its rich traditions, including its technical and performative antecedents. Presently one can see the influence of "alternative processes" ways of thought in works not normally associated with those ideas: in Robert Frank's collages and mixed-media pieces of the past decade, in Mary Ellen Mark's platinum prints, in Mike and Doug Starn's taped-together celluloid assemblages. And one can of course see those ideas actively and consciously investigated by a far-flung cohort of contemporary image-makers involved in what this book's authors call "enhanced photography," whose possibilities they lay before you here by gathering a judicious sampling of the current variations and inviting you to share their makers' thinking—about photography, about art, about craft, about technology, about creativity, about strategies of facture and the complex functions of the photograph as a physical object. This volume demystifies that which still can seem arcane, and provides a clear sense of what pulls picture-makers as radically divergent as Tom Mezzanotte, Judy Natal, and John Reuter to these ways of working.

Whether you are a member of the medium's ever-widening audience, a student or teacher of photography, or a specialist in the field, I think you will find much here to nourish your interests and deepen your understanding of these interrelated yet very different paths to praxis. I think the young woman I mentioned at the outset, she who sent me that naive letter, would profit from it too, so I hope she finds this book; here she'll discover the good and sizable company she doesn't yet know she's in.

— **A. D. Coleman**
Staten Island, New York
June 1998

A. D. Coleman's recent books include *Depth of Field* (University of New Mexico Press) and *The Digital Evolution* (Nazraeli Press); *American Photo* named him one of "the 100 most influential people in photography in 1998." His interactive newsletter, "C: The Speed of Light," appears on the World Wide Web at www.nearbycafe.com.

INTRODUCTION

Our choice of four primary sections—the Transformed, Installation/ Constructed, Extended, and Digital Image—along with a gallery grouping, is a somewhat arbitrary separation intended to assist readers in understanding our efforts. In looking for a way to categorize photographers so as to allow their work to be seen within a particular context, we found that crossover between sections not only became possible, it was inevitable. As the interviews progressed, one thing became evident—the photographers chosen for each section were united by their interpretation of the medium of photography, by the nature of the imagery, and sometimes by the technique. Whether it is Francois Deschamps alluding to an image becoming a physical object in its own right, or Thomas Mezzanotte's desire to create the physical presence he felt was lacking in the straight silver gelatin print, or Ernestine Ruben's desire to see her images break free of the photograph's surface—all suggest the need to create images that move beyond the photograph as an analogue of reality.

For many, however, photographs still function as a window on the world, giving us a glimpse of the reality we know and understand. This representation of the world is fundamentally informative and based upon a belief in the essential truth of the photographic image. It is this sense of truth that opens for photography a legacy of power. When we view a photograph, we are drawn to believe that what is being photographed exists, and that it exists in the context presented. This belief has, for its roots, the very genesis of nineteenth-century response to the photograph. Consider Samuel Morse's description of a daguerreotype in 1840, ". . . they cannot be called copies of nature, but portions of nature herself . . . ," and much more recently, Beaumont Newhall: "The camera records what is focused upon the ground glass. If we had been there, we would have seen it so. We could have touched it, counted the pebbles, noted the wrinkles, no more, no less. However, we have been shown again and again that this is pure illusion. Subjects can be misrepresented, distorted, faked. We now know it, and even delight in it occasionally, but the knowledge still cannot shake our implicit faith in the truth of a photographic record."

It is curious then, and quite telling, that so much of fine art photography today is concerned not only with the medium's naturalistic ability but also with its efficiency at depicting a range of associations beyond the truth of its surface. The images presented in this book have essentially abandoned the concept of a photograph as a window on the world, an analogue of reality. We have learned that a picture is not always about the reality it portrays. It has the power to speak beyond the subject and the more literal allegories of the nineteenth century. It can and has become an aesthetic and/or conceptual object in its own right.

The photographers sharing their work here are all drawn to use the medium of photography in such a way as to modify what the camera has initially recorded. Something moves them to use what has proven to be the most suitable instrument for recording objective reality that the world has ever known, but to use it as a tool for revealing more than the objective world presents them. Some photographers find themselves responding to a synthesis of the reality we share, and the associative image existing simultaneously in their mind. The result is an image that attempts to communicate an inner vision of what the subject itself has revealed. The physical reality, embodied by the subject, has been somehow enhanced or extended through this synthesis. In fact, the photograph becomes far more than a record of what was photographed. It becomes its own object— and what it has to communicate may or may not have anything to do with the actual subject matter that was photographed. The original subject, catalyst for the image, is no longer the key reality.

In one sense, the fundamental difference between a dream and reality is one of continuity in time. In a dream, time and form can change without question, apparent motivation, or even conscious will. When we awake, we are aware of our shift in consciousness, and take up our sense of continuity—breakfast by eight, work by nine, and so on. We can and do plan days, weeks, and even years in advance, and have some assurance of our ability to continue relating to those time frames. The moment of cognition (in all its many forms) that moves artists, relates very strongly to our sense of the dream state. There is no shared continuity in time, no single form the experience holds. The image resulting from that moment of cognition exists in our mind as an abstract of essential form slowly synthesizing with and dissolving into memory. For whatever reason, the artist finds it necessary to act, to bring the essence of this cognitive experience into a more tangible form, allowing that essence to metamorphose into an image representing the experience. By producing an artifact representing this "dream vision," the artist is, in fact, giving that vision continuity in time; bridging the gap from dream state to reality, and so, shared consciousness. It is only after viewing a body of work by a particular artist that we begin to note meaningful patterns and recurrent imagery as the artist develops a personal symbology to deal with his or her perceptual/conceptual vision.

In practical terms, these artists have used the medium of photography to mediate their vision to the world. They have integrated image and medium to form a powerful interpretive tool—a tool that does not celebrate by rote the "decisive moment," or the fundamental beauty of an unmanipulated silver print, but the unleashed imagination coupled with the power of the photograph to suggest truth.

THE TRANSFORMED IMAGE

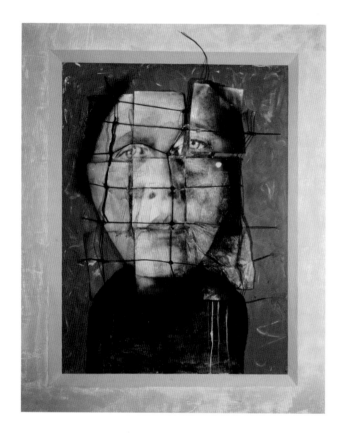

Ollipsus
Thomas Mezzanotte

Struggling with the photograph's power to document, artists have sought ways to break the "magic mirror" and portray a variety of more personal realities that can shift our perceptions of the medium. Often, this shift has been accomplished by subverting photography's ability to record the minutia of the world. Images have been solarized, negatives microwaved to reticulate the gelatin holding the emulsion, and prints and negatives abraded to delete information and stress the surface to destroy the illusion of reality. Textures have been used to obscure detail, images superimposed, made into prints using archaic methods, hand-colored, made into

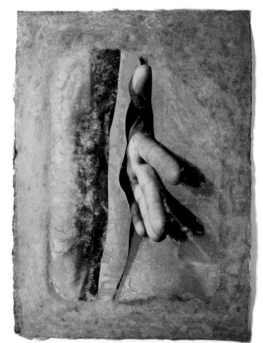

Peekaboo Fingers
Ernestine Ruben

From Series "No Man's Land"
Morel Derfler

boxed transparencies, quilts, pillows, and more. Even Polaroids, those instant photographs that provide impromptu glimpses of the world, have been ripped, smushed, rubbed, and even transferred from their original substrate to a variety of other surfaces, producing startling views of an unimagined world.

This section delves into imagery that extends the photograph beyond its manifestation as an analogue of reality. While the truth value of a conventional photograph is undeniable, the artists presented here are pushing the unique, expressive qualities of the medium in order to transcend conventional boundaries. Whether it is Ernestine Ruben's organic figures coalescing from the surrounding and surprisingly atmospheric paper pulp, or Morel Derfler's iconic animals shimmering into existence, we are faced with a fundamental redefinition of photographic aesthetic. Similar considerations arise from the work of Luiz Guimarães Monforte, who presents us with symbolic, nonlinear images, and Thomas Mezzanotte, whose huge portraits are a masterful combination of arcane techniques. Together, these images suggest a photographic paradigm shift of profound dimensions.

Inside the Dungeons of the Imagination III
Hopscotch Series
Luiz Guimarães Monforte

constructing
layers of illusion

Ernestine Ruben

background and influences

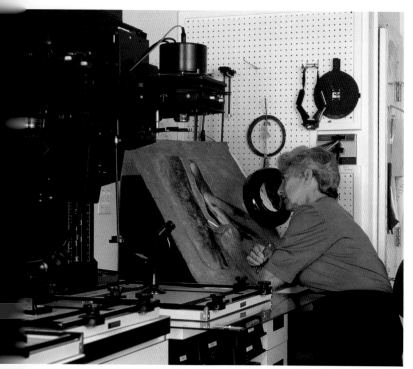

It was not until the age of forty-seven, after raising her four children, that Ernestine Ruben discovered photography—and she has not looked back. In the past twenty years Ruben has had more than fifty solo shows in the United States and abroad, has produced four monographs, and has contributed to major collections in France, Holland, and the United States. Ruben's willingness to push the boundaries and rules of photography has taken her work far, despite her "late-blooming" interest in the medium. "Our lives change," she says, "when we learn to see differently."

Many of Ruben's influences go back to her childhood. Her mother was a professional art collector, and Ruben was exposed at an early age to a home full of some of the twentieth century's most influential art. She developed an appreciation, understanding, and respect for the famous artists of the era. Most influenced by Brancusi, Arp, and the Futurists, and ultimately by the movement of the human form, she went on to study sculpture in college and worked primarily with the human body. The human form became a central theme in her photographic work, as it is in her life. The art she surrounds herself with, the furniture she chooses (and in one case designed), and even her backyard landscaping (which she designed in collaboration with a landscape architect)—all reflect the soft curves of the human form.

Collaboration is nothing new to Ruben; she feels that open dialogue and exchange between artists, scholars, and professionals in other fields expand one's vision and universe. The body of work presented here reflects two such collaborations.

Ruben's extensive photography of professional dancers led her to collaborate with a choreographer on some of the initial images used in this work. Together they worked to emphasize certain human gestures in response to Ruben's earlier work with the figure. Furthermore, her involvement with papermaking reflects a strong collaboration and friendship with master paper maker Paul Wong at the Dieu Donné paper mill in New York, where she created this body of work.

Ernestine Ruben's work combines the silver or platinum image (in this case silver) with the natural recycled materials of papermaking, such as paper pulp, vegetation, grasses, and leaves. She finds many of these materials in her own backyard.

At the paper mill she uses three layers of pulp—cotton, abaca, and linen, each having their own properties of opaqueness and texture. Using squeeze bottles, she mixes up to fifteen natural-colored pigments with paper pulp to use in painting and sculpting the image.

The technical challenges are many: the first is how to subtly blend the silver photograph into the cotton paper backing. Tearing selectively around the photograph edge, she places it on the cotton backing and manipulates the paper pulp with her hands, much as a sculptor works with clay. The three different layers of natural pulp are then added one by one. Since the paper pulp particles are suspended in water, once the pulp starts to dry there is no going back— adding water will only make the pulp flow away. Rubens has only an hour to complete these layerings, all the while manipulating the material with her fingers to cover or reveal the photograph underneath. Once the hour is up, a blotter is placed over the work, keeping many of the fine details a mystery until it is removed four days later.

Ruben believes that "photography in its search for expressiveness or beauty, can sometimes silence the very life it seeks to convey by aestheticizing reality, framing it, and cleaning it up." By connecting and layering her abstract figurative works with various organic materials, she seeks to emphasize the life force of the human form. Because of the strong, optical dimensionality of the technique and work, this life force literally shines through—breaking the two-dimensional surface.

Constructing the Image

Working in a studio at Dieu Donné paper mill (NYC), Ruben employs about fifteen to thirty varieties of paper pulp prepared in three different levels of opacity. After tearing her prepared images (either silver or platinum prints) into the shapes needed for her constructions, she glues the image onto the paper backing sheet, then paints and sculpts it with the prepared pulps. Sheets of transparent abaca are kept ready to overlay new skins on the figures where necessary. Often, the pulp goes through a series of transformations as it dries, yielding sometimes surprising results. Pulp may darken or even disappear entirely, depending on its level of opacity.

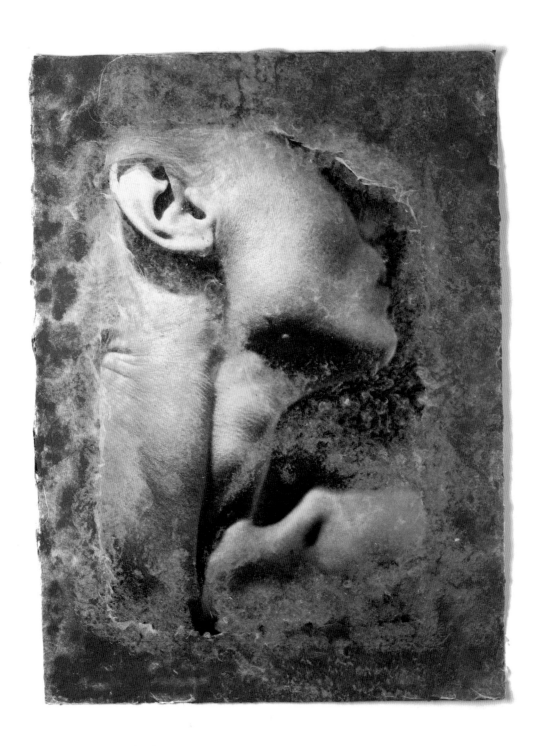

Big Profile

32" x 24"

(81 cm x 61 cm)

Silver print with paper pulp

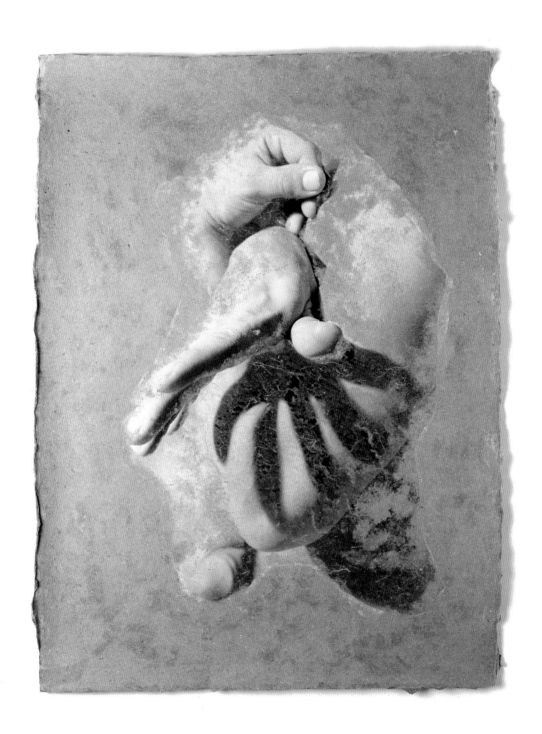

Finger Shadows

32" x 24"
(81 cm x 61 cm)
Silver print with paper pulp

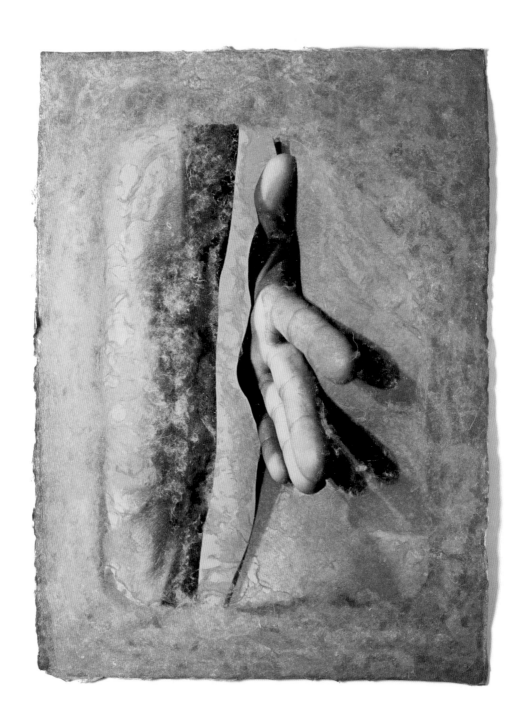

Peekaboo Fingers

32" x 24"

(81 cm x 61 cm)

Silver print with paper pulp

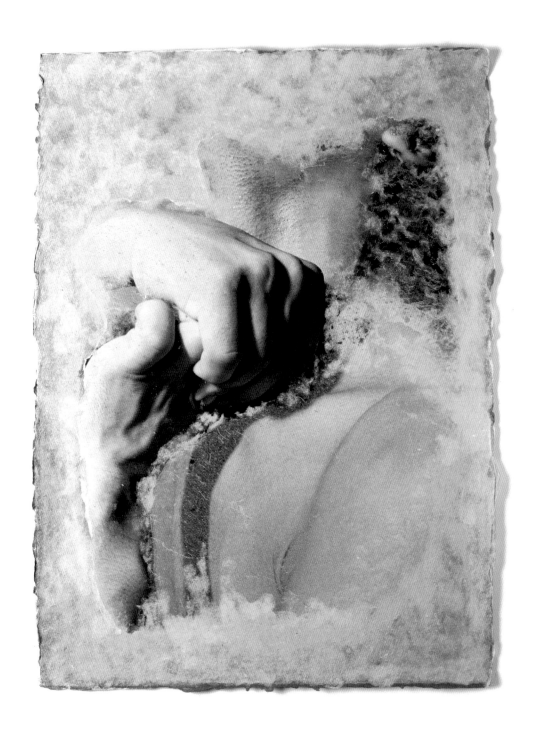

Large Fist

32" x 24"
(81 cm x 61 cm)
Silver print with paper pulp

mythic fragments

Morel Derfler

background and influences

Born in Romania, Morel Derfler immigrated with his family to Israel in 1961, when he was five years old. Fifteen years later, looking for a means of personal expression in his life, photography found him ready and waiting. It seemed to him then that photography was a startling and unique language—one that would allow him to express feelings as well as ideas.

Graduating from the photography department at the Wizo Neri Bloomfield College of Design in Haifa in 1981, Derfler immediately began to teach there. He also began to show his work to an ever-widening audience, with exhibitions throughout the world. Ten years later, watching his five-year-old daughter create stories from the interactions of her little toys, he realized "those interchanges and relationships touched the very basis of human existence." At that point he began to create and photograph intimate still lives using small models and toys. He also began to abrade and scrub and delete information from the negative itself to create a visual field that removed the image from its more pedestrian origins. Though not intended as such, these images somehow spoke eloquently about life in Israel and the human condition in general.

Currently in the United States with his wife (temporarily transferred from Israel by Intel, for whom she works), Derfler has been active in giving workshops throughout the country and in sustaining his personal work. Unsure if he will continue to use manipulated images to re-create reality or simply "take reality and leave it as it is," he feels the real change and challenge will take place when he returns to Israel.

Derfler describes the process he uses in manipulating images as a "basic need to broaden the creative activity—expand it to add new information, which does not exist when the button is pressed to take the photograph. The final work is a result of visual images combined with intimate information flowing up from my own feelings."

Using common objects and simple miniature plastic toys as subject matter, Derfler creates a photograph in which the images rapidly lose their original meaning. Placed out of context and proportion, and combined with Derfler's abrasions on the very negative itself, they become "magic symbols or artifacts for unexplained rituals—both playful and serious at the same time."

These new images, though photographs, are now missing one of the essential qualities inherent in photography: instantaneousness. The work of scratching the negative produces contradictions between the photogram-like silhouettes, and the personal, sentimental manuscript represented by the scratches. While most photographers are pristine in their efforts to produce a flawless negative, Derfler's use of sandpaper on the negative to obliterate information and create a new stage on which to work, questions the very nature of the medium. The technical challenge of Derfler's work resides in the difficulty of combining the visual representations of the toys with his manipulations and then bringing them together as one reality.

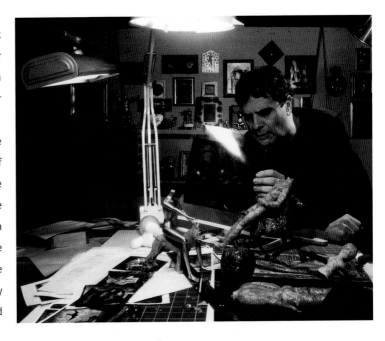

His image of the jaguar is a case in point. Timelessly balanced on a black monolith, floating in a field of swirling color, enclosed by a box of darkness punctuated with red threads that hold it in place, the jaguar seems forever waiting for some moment of decision. One feels the presence of a myth yet untold that is only waiting for a listener.

Erasing the Image

Derfler's technique follows a clear progression. Initially he stages the toys—creating the basic form of the image. He then photographs them. Once the negative is developed, he works on it with sandpaper and other materials to obliterate and reintegrate the actual object being photographed. This creates the background and spatial relationships he seeks. He then prints the negative on silver gelatin paper and sepia tones, and hand-colors the print.

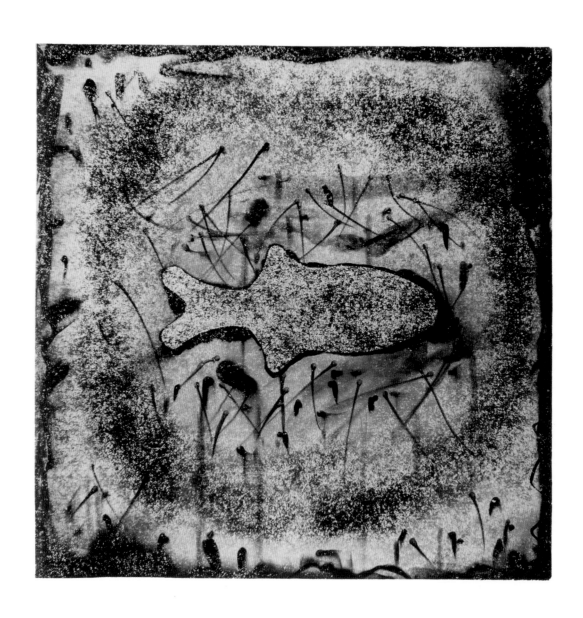

From Series "No Man's Land"

18" x 18" (46 cm x 46 cm)
Toned and hand-colored
silver gelatin print

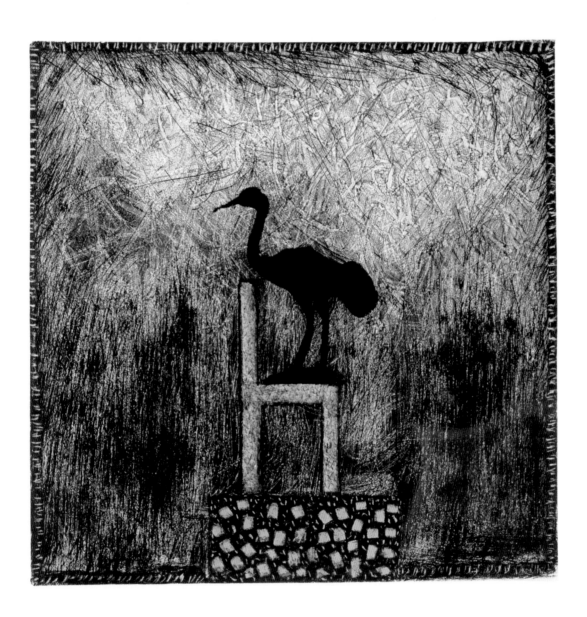

From Series "No Man's Land"

18" x 18" (46 cm x 46 cm)
Toned and hand-colored
silver gelatin print

From Series "No Man's Land"

18" x 18" (46 cm x 46 cm)
Toned and hand-colored
silver gelatin print

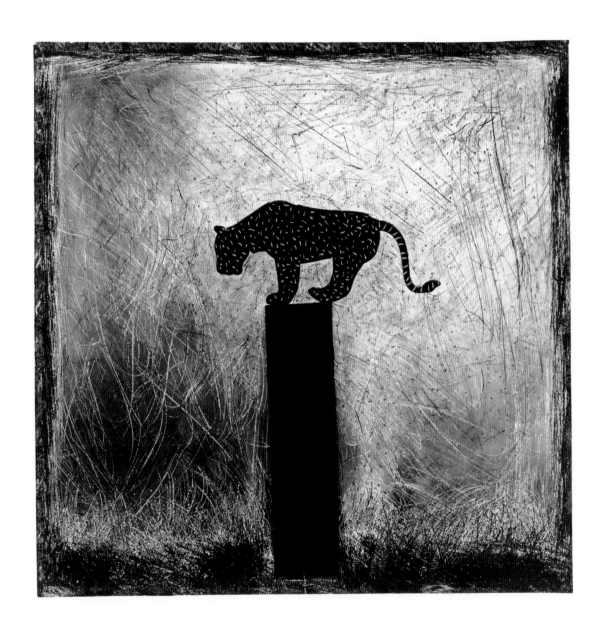

From Series "No Man's Land"

18" x 18" (46 cm x 46 cm)
Toned and hand-colored
silver gelatin print

nonlinear moments

Luiz Guimarães Monforte

background and influences

Brazilian photographer Luiz Monforte traces the roots of his photography to the drawing classes he took in elementary school, the images produced in the 1960s by photojournalists for the magazine *Realidade,* and to his first photography professor at the Philadelphia College of Art, where he originally intended to study art therapy. When the professor predicted he would become a photographer, Monforte found the motivation to attend the Rochester Institute of Technology, where he studied under a CAPES grant from the Brazilian Ministry of Educational Affairs. At RIT he interacted with unforgettable teachers and fellow students; and he credits their teachings and influence for his true beginnings as a photographer.

One might wonder how primary-school Latin and French courses, recorded opera solos played by his father during Sunday meals, the work of contemporary musicians such as John Cage, and trips to São Paulo to see theater, dance, and international visual arts exhibits could possibly converge to produce the photographer Monforte is today. The path to his destination has been a meandering one, full of side-trips and nonlinear detours. Yet consider his respect for artists like Albrecht Dürer, Oscar Rejlander, Eugene Atget, Joseph Cornell, Marcel Duchamp, and Robert Rauschenberg, whose "allegorical approaches neutralize a linear reading of their work, turning images into precise metaphorical chronicles of their times." As the contextual parallels between Monforte's life and his work become evident, one begins to understand why he feels photography's most attractive quality is its "subversive figurative potential."

Most of Monforte's work is non-silver in origin. The conventional silver print, in his opinion, corresponds to an exact and linear technical procedure with the photographer playing just a part, albeit an important one, in the process. Silverless processes, he believes, "detonate" a searching or researching where the photographer is not a mere agent capturing images, but "someone who actually lives in the process. The non-silver printer establishes the rules, constructs ideas, expands and broadens them, and in so doing, qualifies his experiences."

The "Hopscotch" series uses several printing methods for their rich palette and variety of chromatic ambiance. The images are a montage of puzzle pieces to be constructed by the viewer. Their modular nature reassures with its logical, linear structure. Yet the symbolic, visual fragments and variety of chromatic atmospheres constantly fight this linear approach, forcing the viewer to break down the conventional reading—to start and restart history in an attempt to decipher it. Monforte feels that in this way the works mimic the decidedly nonlinear chain of events in one's life.

The "Window/Windowmaker" series was inspired by the rich, baroque atmosphere of Brazilian colonial cities. The "Gilgamesh" series had its origins in the Epic of Gilgamesh.

Monforte describes his working process as a series of steps based on the semiotic theories of Charles Sanders Peirce: (1) Find a story, and in that story develop a dialogue with the history of art. (2) Check your bank account to see if the story needs to be edited. (3) Get out to where the wind blows with a 35mm camera, hunting for the characters and places to tell the story. (This can take months or years.) (4) Edit the images—adding images from your archives if necessary. (5) Produce enlarged halftone negatives on Kodalith Type 3 film or scan the originals into digitized transparencies. The enlarged negatives are contact-printed on newsprint to check quality. (6) Final prints are usually contact-printed on Rives BFK paper or printed digitally on *Papier des Arches* on a large-plotter printer.

Persistence

Technically, Monforte faces few problems with chemicals, cameras, or computers, all of which are readily available in Brazil. Quality paper is a challenge, however, and often he must find sources abroad. He credits much of his creative energy to reading, listening to his students, long lab hours, and music. "I am also gifted," he says, "with the quality of persistence."

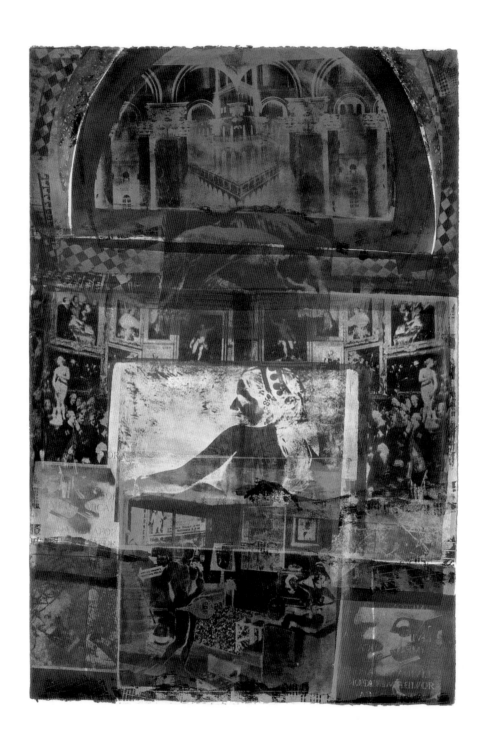

**Inside the Dungeons
of the Imagination III
Hopscotch Series**

44" x 33" (112 cm x 84 cm)
Mixed media: gum, Van Dyke,
cyanotype, and thermography

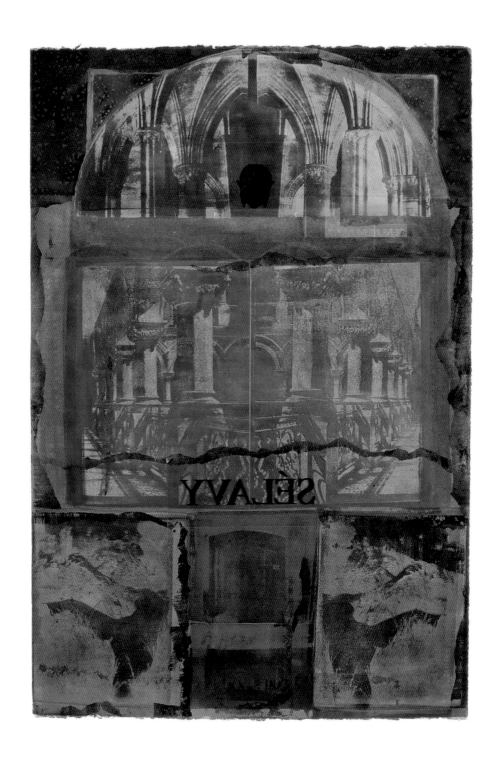

Sélavy
Hopscotch Series

44" x 33" (112 cm x 84 cm)
Mixed media: gum, Van Dyke,
cyanotype, and thermography

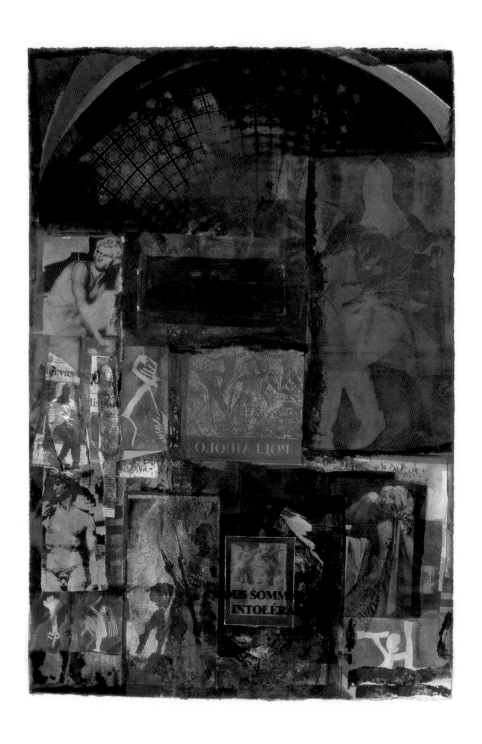

**Considering
Benjaminian Premises II
Hopscotch Series**

44" x 33" (112 cm x 84 cm)
Mixed media: gum, Van Dyke,
cyanotype, thermography,
and collage

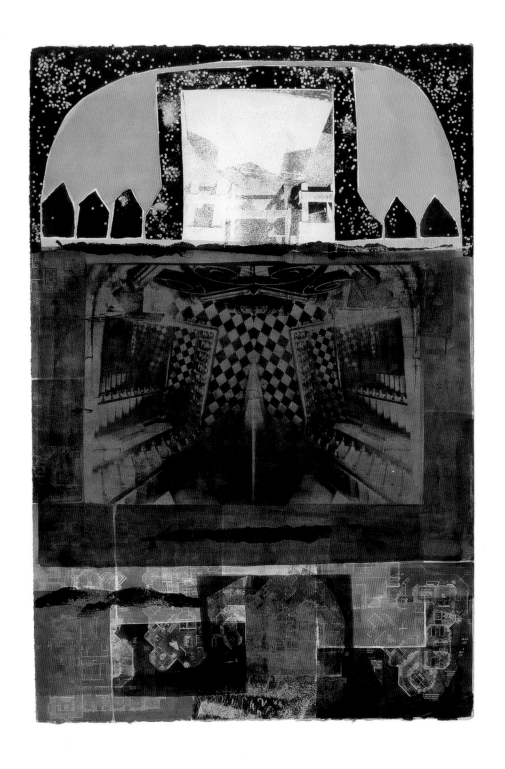

**Inside the Dungeons
of the Imagination I
Hopscotch Series**

44" x 33" (112 cm x 84 cm)
Mixed media: gum, cyanotype,
and thermography

Thomas Mezzanotte

background and influences

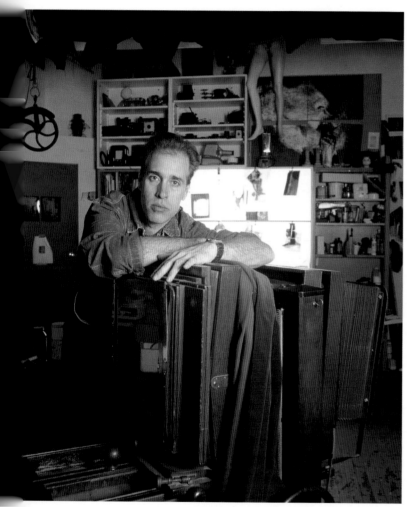

As an adolescent in the late 1960s, Thomas Mezzanotte discovered refuge in the high school darkroom. Although he admits this was at first a way to dodge the "enemy" (anyone over the age of thirty), he was immediately captivated by the medium's magical properties.

At the University of Bridgeport, where he was originally studying optics, Mezzanotte was exposed to many of the non-silver processes he continues to use today. Because of what he describes as the serendipitous environment of the art department at that time, he was inspired to change majors and immerse himself in a creative atmosphere that encouraged artists from all mediums to experiment and to cross genre lines.

One of his early mentors, Roger Baldwin, introduced him to the book *Keepers of the Light,* which Mezzanotte used as a cookbook, experimenting with the various chemicals and processes. "I did most of them, but eventually fell in love with palladium for its beauty, and gum bichromate as penance. (I am a Roman Catholic by birth.)" Despite the difficulties and crudeness of the process at that time, he marvels that "the platinum/palladium process was alchemy—it was magic manifest in metallic salts."

Believing that life's experiences directly influence art, Mezzanotte works on an image while reading, driving, traveling, and living in the moment. "We are all products of our perceptions," he says. "The richness and depth that art is a reflection of—that is what I hope is communicated in my work."

Exposure to the literary works of Argentinian writer Jorge Luis Borges has had a great impact on Mezzanotte's work. Borges' idea of reordering the natural sequence of things directly motivated Mezzanotte to break the rules, take risks, and ultimately grow through the work. His ideas develop out of the work, not vice-versa.

Another great literary work that influenced Mezzanotte's thinking and ultimately his work, was Thoreau's *Walden.* For Mezzanotte, the key element in this book was the idea that the most important journeys in life are taken inwardly—with the mind. After visiting Mezzanotte's quirky, converted factory studio, and seeing the resulting works, it is clear that this journey is a fascinating adventure indeed.

Attracted to the texture of peeling paint on an old barn or the richness of surfaces in rural junkyards, Mezzanotte struggled to render these subtle yet beautiful textures in silver gelatin tones. Dissatisfied, he realized the image had lost what had attracted him in the first place—the quality of the surface. He says "it represented but didn't reproduce."

The moment Mezzanotte discovered alternative processes, he recognized what he was looking for—a way to create the very surfaces he had been seduced by. "It was not the image of the surface that I was after," he says, "but rather the surface itself."

Mezzanotte often photographs his subjects with a 20" by 24" (51 cm by 61 cm) view camera reconstructed from an inherited copy camera rendered obsolete by the computer. He added a hundred-year-old lens, and mounted this rig on wheels in his converted factory studio. Most often he uses single-weight paper negatives (Dupont Varilore), preferring them to film because of their soft, atmospheric quality. The paper negatives are then contact-printed in the desired manner to produce a positive.

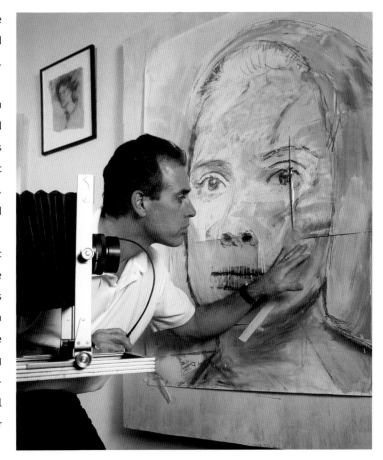

Mezzanotte constructs his images using a variety of photographic processes, collage techniques, and mixed media. Often, as with "The Autobiography of an Image," he layers fragments of a particular process, such as cyanotype and palladium, over his original toned silver print, sometimes in registration and sometimes not. Another technique he uses often is the sheathing of a semi-transparent rice paper, added in sections over the existing photograph, followed by a coat of shellac. The rice paper gives the image a non-uniform and wonderfully textural and eroded quality. There is an archeological feeling about the pieces. "The surface reveals the substance," he notes, "layer after layer."

The Portable Studio

To make such large negatives, Mezzanotte places the empty back of his camera four feet from the studio wall and builds a light-tight tent out of old theater curtains, thus connecting the camera to the wall. He enters the tent to pin sheets of photographic paper to the studio wall. The camera lens must be opened for several minutes of exposure to create the paper negatives. Slight movement by the subject is common and most often looked upon favorably. "Ollipsus," which measures 72" by 60" (183 cm by 152 cm) wide, is a good example of this technique, With this, as with many of his other pieces, Mezzanotte relies on plaster and oils to complete the massive work.

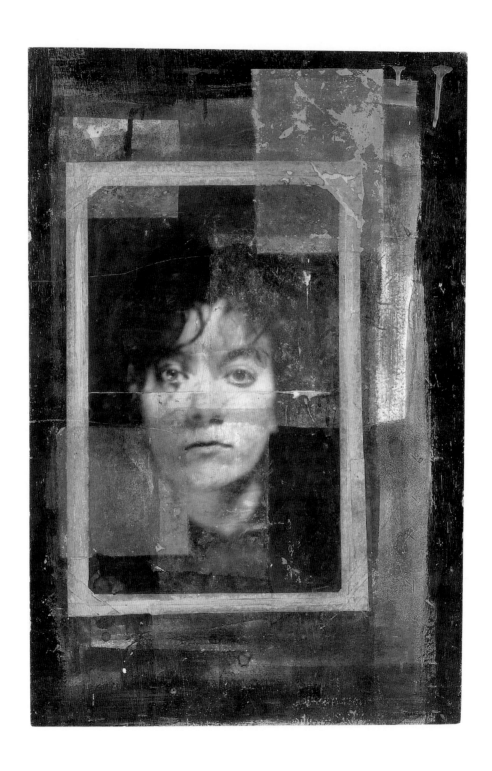

Dawn

35" x 23" (89 cm x 58 cm)
Toned silver gelatin, shellac, rice
paper, pigment, masking tape

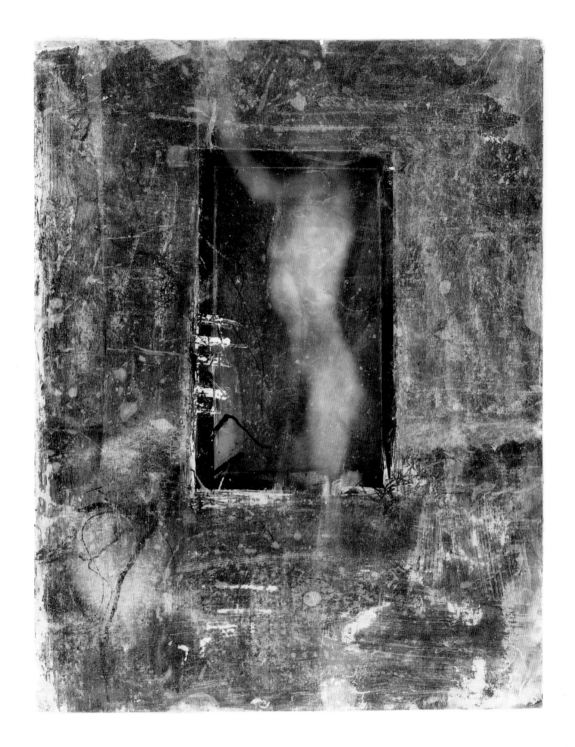

Bedeutungsschwer

14" x 11" (36 cm x 28 cm)
Toned silver gelatin, rice
paper, shellac on panel

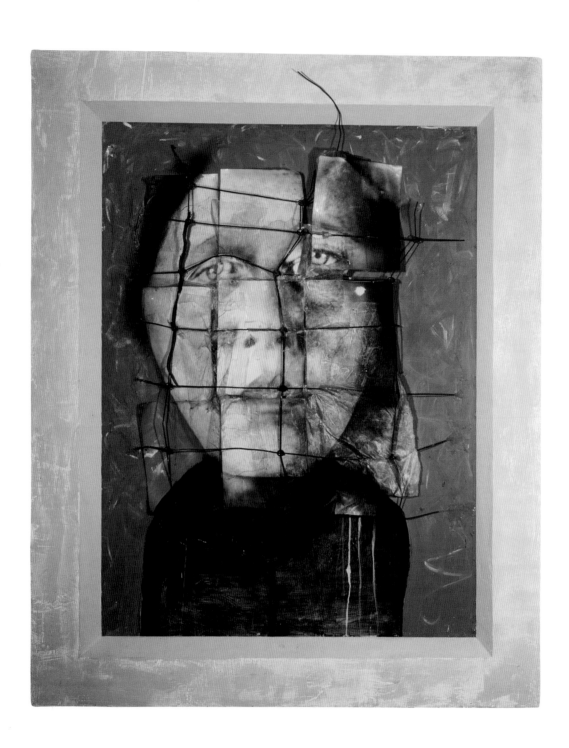

Ollipsus

72" x 60" (183 cm x 152 cm)
Toned silver gelatin, rice paper,
shellac, wire, oil paint, graphite and
plaster on wood.

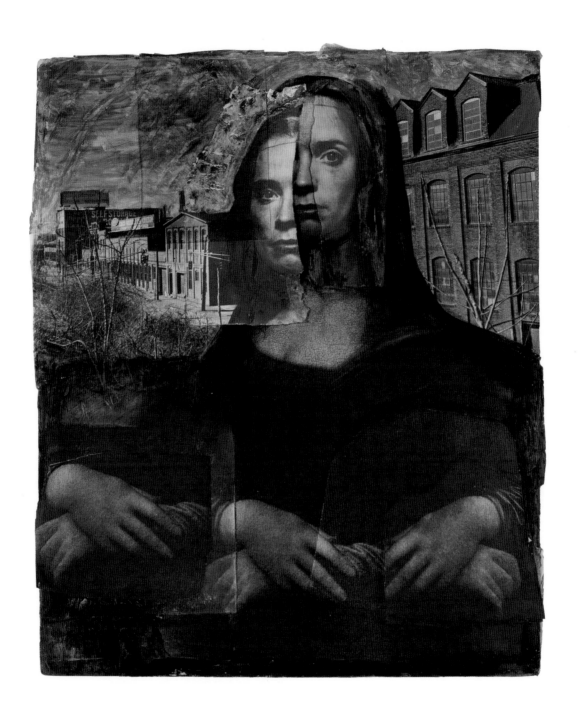

**The Autobiography
of an Image**

28" x 24" (71 cm x 61 cm)
Toned silver gelatin,
rice paper, shellac

INSTALLATION/CONSTRUCTED IMAGE

For some photographers, concepts and ideas are more important than the medium itself. In fact, they often find a single medium far too limiting, a single print only a fragmentary allusion to the ideas they wish to convey. For such photographers, the interaction of the spectator is an integral part of their work. Rather than presenting the viewer with images on a wall, they expect the viewer to pick up, hold, and perhaps even move around the works. Even so, images can serve to document the nature of the installation, to convey at least the sense of the experience.

Visitors
Rachel Murray

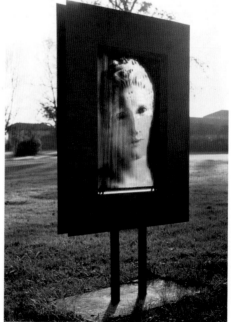

Photograph on Glass
Keiichi Tahara

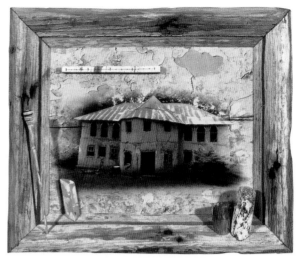

Palace: Foumban, Cameroon
Francois Dechamps

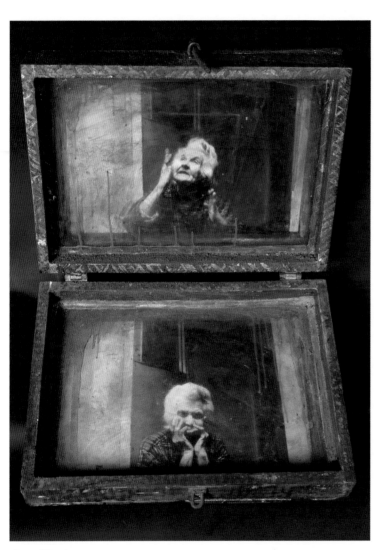

Rose of Sarajevo
Tim Pershing

This section on the Installed/Constructed Image offers the work of photographers who present a synthesis of image and concept, where the one is absolutely dependent on the other: for example, Rachael Murray's installations and their ability to place viewers within the light and shadow of the piece itself, create an immersion experience complete with echoing heartbeats. Francois Deschamps will challenge your perceptions as he transforms photographic images into meticulous, three-dimensional constructions that create new questions about the nature of spatial relationships. Tim Pershing also offers sculptural images, but with a profound connection to the human condition, and Keiichi Tahara's large, organic installations take you into the real world of sun and light. These are photographers who seek to explore the medium as a carrier of ideas, not necessarily as an aesthetic object in and of itself.

constructions
of illusion

Francois Deschamps

background and influences

A traveler at the age of eleven, when his family allowed him to journey alone by ship to visit relatives in Europe, Francois Deschamps has been an inveterate voyager ever since. Photography has become a natural extension of his expeditions and his life. Whether traveling to Haiti, South America, or the Fiji Islands, he folds his life experiences seamlessly into his image making.

Born in Manhattan as the oldest son in a bilingual family, Deschamps learned English when he was five years old and attended a French elementary school in New York. While completing course work for a doctorate in mathematics at the University of Illinois, Deschamps became interested in photography after taking a class with Art Sinsabaugh. This led to a profound change in direction and the completion of a Master of Science degree in photography at the Institute of Design in Chicago, where he studied with Aaron Siskind, Arthur Siegal, and Gary Winogrand. He went on to teach at Bradley University in Peoria for seven years before coming to the State University of New York at New Paltz in 1980, where he is now the Chair of the Art Department. During that time he has received two National Endowment for the Arts fellowships in photography (among many others) and has published several books about his work. The most recent of these is *Mémoire d'un Voyage en Océanie*—an examination of the "apparently ill-fated voyage of the *Curriodity*," a mythical schooner and its adventures exploring Australia at the beginning of the twentieth century. Not surprisingly, the main character is none other than—Francois Deschamps.

Deschamps's bipolar interest in photography has moved from the conventions
of straight image making taught at Chicago's Institute of Design to meticulous
three-dimensional constructions that challenge our sense of the photograph as
image and object. Recognizing his fatal attraction to the nontraditional aspects
of photography (which he feels are not always rewarded in the marketplace), he
nonetheless believes that a straight image is not enough. He wants his images
to assume dimension, to become substantive, to become *objects*. Interested in
the narrative quality of photographs, his constructions offer a dimensional
experience beyond that which a straight silver print can offer.

Part photographer, part carpenter, part model maker, Deschamps rides
an edge that sometimes startles, and sometimes hints at the profound
relationships between the image and the space it inhabits; the constructedness
of the space is an integral part of the final image.

He is committed to the construction and deconstruction of his images,
which tend to be wonders of illusion. Old weathered wood forms the base for
delicately layered photographic emulsions, and the images seem to spring from
the surface or sit behind the native textures of the wood itself. Resting in
shadow-box frames, these fragments of fantasy offer both visual delight and
surprising associations. As the viewer moves closer, the illusion is broken and the
work becomes a simple collection of pieces of wood, of a cardboard outline—a
collection of photographic fragments. This duality of form refers again to the
image created in the mind of the viewer, which may or may not relate to the
actual object presented. The image as object creates a delicate resonance within
the viewer willing to suspend disbelief.

Registering Reality

For these pieces, Deschamps first photographs the piece of wood
from which the box will later be built. The photographic image of
the piece of wood is enlarged exactly life-size so that it can
seamlessly and illusionistically overlay the original piece of wood
that was photographed. He then multiple-prints the photograph of
the historic scene onto that image of the wood, blending the two
together. When placed in register with the real wood, this
photograph helps create a veil of time within the piece as the
metamorphosis unfolds.

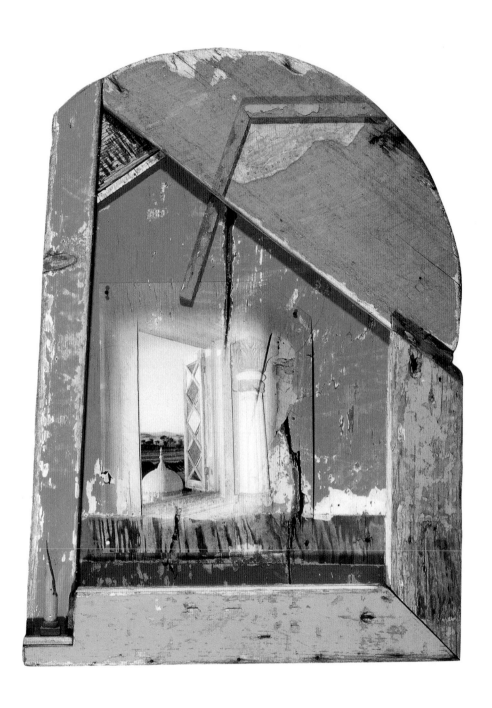

Window: Jaipur, India

24" x 16" (61 cm x 41 cm)
Wood, liquid emulsion,
shadow-box frame

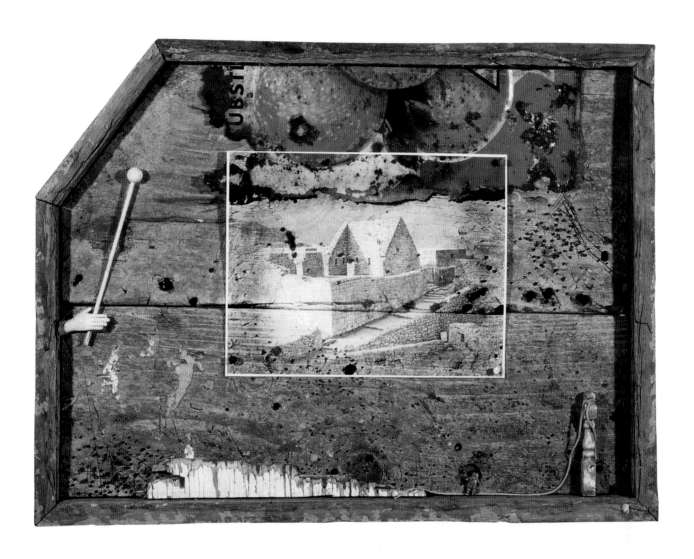

**Machu Picchu,
Orange Crush**

16" x 22" (41 cm x 56 cm)
Wood, liquid emulsion,
shadow-box frame

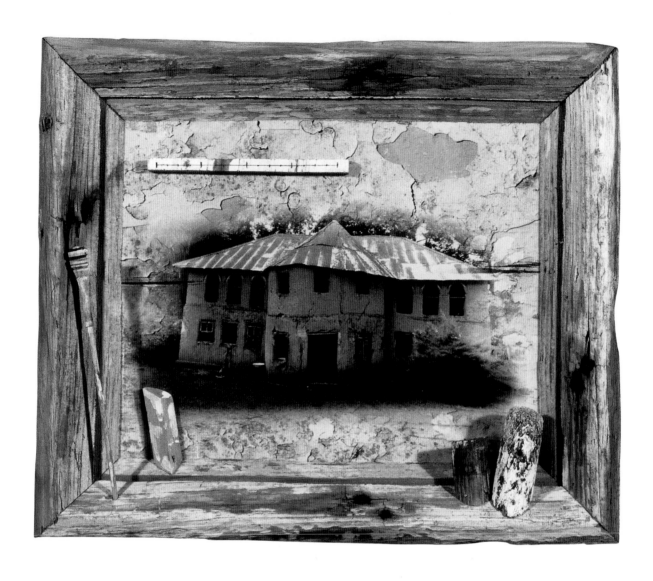

Palace: Foumban, Cameroon

12" x 14" (30 cm x 36 cm)
Wood, liquid emulsion,
shadow-box frame

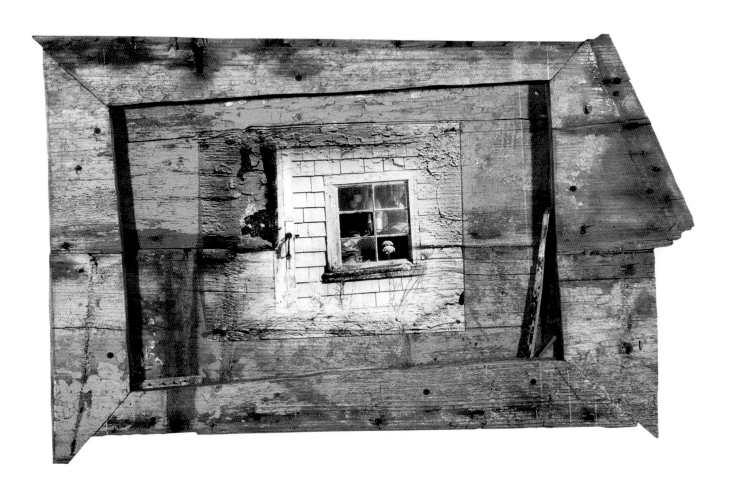

Lobsterman's Shack:
Vinalhaven, Maine

16" x 24" (41 cm x 61 cm)
Wood, liquid emulsion,
shadow-box frame

light and shadow

Rachel Murray

background and influences

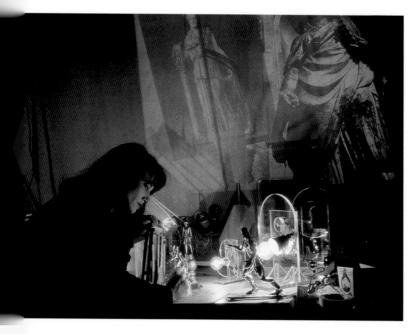

Rachel Murray was always making art and objects as a child, and this kind of activity—creating objects and experimental environments—still comes naturally to her. In high school her artwork was put on hold so that she could take additional science courses, and it was not until college that her two interests reconverged. While earning an undergraduate degree in mathematics at Smith College and a master's in industrial engineering from the University of Massachusetts at Amherst, she turned to art courses as a release. Struggling with drawing, she decided to take a photography course, feeling this might be a faster form of expression. She did not own a camera, and had to select one from a bin of loaners. The one she grabbed was an old twin-lens 2 1/4 Rollei, and she has been using a square-format Rolleiflex ever since.

In 1986 Murray met photographer Edmund Teske, who proved to be a major influence. Teske sought to map an inner spiritual realm using some of the same images over and over again as icons or archetypes. This repetitive use of images broke a long-held taboo for her. Listening to an inner voice, she found herself reusing strong individual images in a variety of ways—straight, layered, projected, and rephotographed. She began a period of spiritual exploration that led to a type of Buddhist meditation involving chant, which along with vegetarianism, she still practices today. She believes these two elements contribute to an ongoing self-awareness and deliberateness that find their way into her work.

Murray has risen through the ranks of corporate America, and is now vice president of quality assurance for a toy company. Describing herself as very analytical, she realizes that both of her chosen paths require acute problem-solving abilities. Inventive and playful, she constantly tries to create something meaningful and of value. As an artist she attempts to blend layers of linear and nonlinear narrative in poetic ways, giving viewers a sense of personal story. "I am fascinated by the uniqueness of how and what we perceive, by the efforts made by our eyes, minds, and memories to piece together these fragmented, multilayered, dreamscape environments."

When an acquaintance who worked in a photo lab told her about a new translucent film, Murray brought in a favorite image, which they printed and mounted on Plexiglas. It was a major turning point; she began to experiment with ways of illuminating and extending images with something other than light-boxes. Initially layering images within Plexiglas casings, she soon began mixing in photocopies and found images. One day, while showing a friend an image under a hand-held light, her friend remarked at how the skeleton in the image's shadow was moving. It was the recognition of this crude form of animation that broke new ground. With her engineering background she could conceptualize the moving light mechanisms, identifying the form of movement and the type of design necessary.

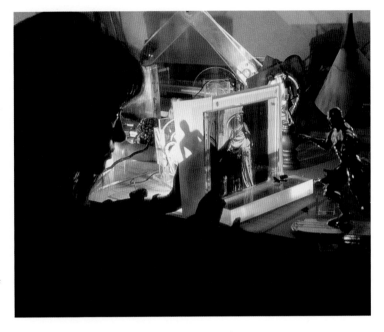

The first mechanism Murray built allowed the light bulb to travel back and forth along a rod. This was later replaced by a device with the bulbs on the edge of a rotating disk. Using clear, spring-filament light bulbs, these units are extremely durable, most of them logging over 1,500 hours without failure. The clear, delicate bulbs throw sharp shadows, and the spring filaments provide a slight quiver to the movement. The movement is also timed and balanced to match natural rhythms of heartbeat and breathing. However, it is the quality of light that moves her. "My love of light finally could only be satisfied by having it as an integral part of the work. The same could be said of my fascination with shadows." Light and shadow—the stuff photography is made of, a paradox of dreamlike dimensions. "Shadows, which are to some extent unreal and illusory, in fact, by their very presence, indicate that something real exists."

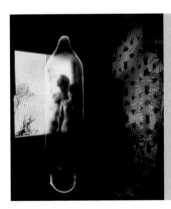

Recipes for Work

Murray identifies two working methods: the "Cooking Method" and the "Sculpture Method." For the "Cooking Method," she assembles, layers, and mixes the ingredients on top of a light table, manipulating the elements until she is satisfied. She then makes a commitment by trapping the mixture between two pieces of Plexiglass and screwing them together.

The "Sculpture Method" reveals an image in her mind. "Suddenly, the old favorite suit, the light-up mannequin, the rotisserie, the trophies, and the fencing mask all have a clear role to play." She sets up the objects and lights them, evaluating the progress by hand with a bare bulb and large sheets of vellum.

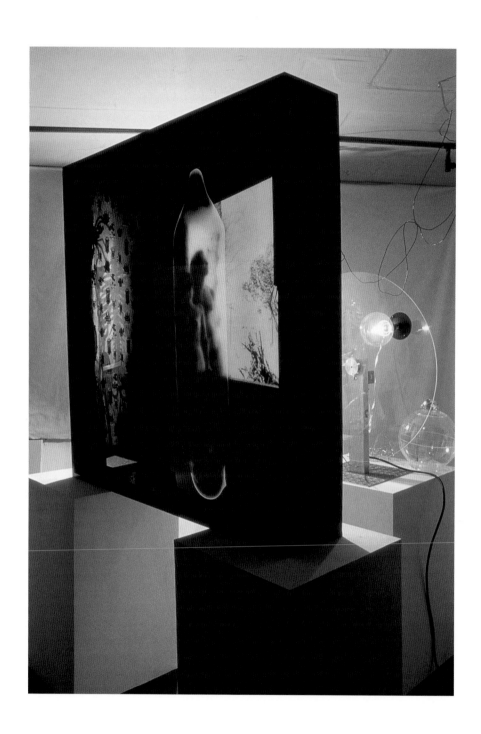

Visitors (side view)

4' x 4' (1.2 m x 1.2 m)
Mixed media

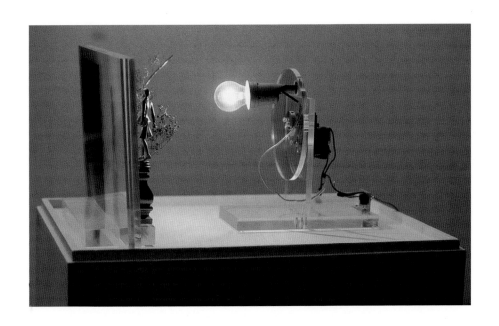

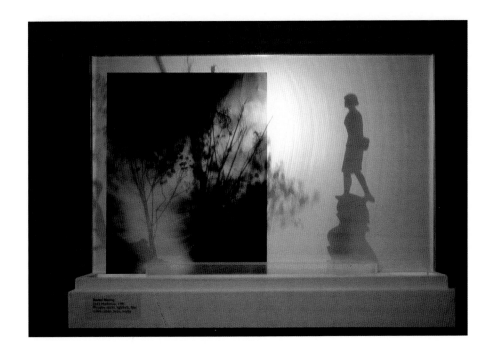

Daily Meditation

(front and side views)

18" x 14" x 24"

(46 cm x 36 cm x 61 cm)

Mixed media

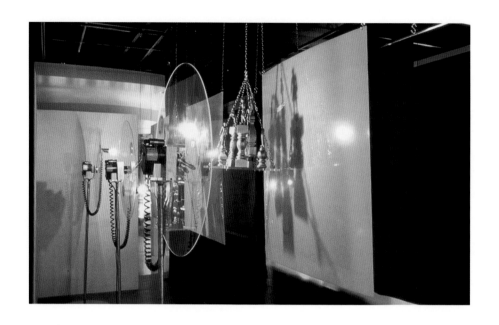

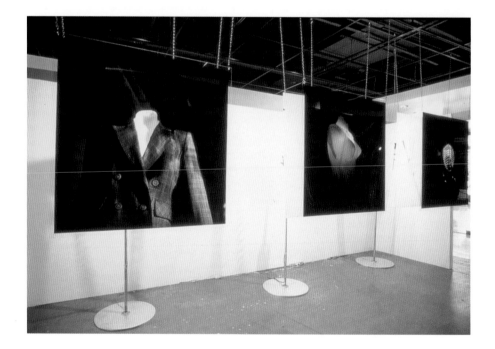

Corporate Specter, Parts 1, 2, 3

(Conformity, Projection, Fear)

4' x 4'

(1.2 m x 1.2 m)

Duroclear photographc images, white Plexiglas sheets,

Plexiglas shelves with plastic and metal objects, and

standing motor-driven lightbulb mechanisms

Name the Disease

9" x 9" x 18"
(23 cm x 23 cm x 46 cm)
Mixed media

a perception of light

Keiichi Tahara

background and influences

Born in Kyoto, Japan, Keiichi Tahara's infancy was marked by a long illness. While lying in bed, he was able to observe the light that played on the walls of his room. That play of light made a profound impact on young Tahara, and has played a major role in his artistic life ever since. Ever since his arrival in Europe, his research and exploration of light has been at the center of his artistic approach. He found that the light in Japan, which is always subtly veiled, had nothing in common with the light of France, which he found harsh, even brutal. He became convinced that the nature of light has its effect on the land, the people—even the language we speak.

While Tahara does not name any direct influences on his work, he does find a resonance with artists such as Man Ray or Moholy Nagy, who have not limited their study to one unique technique. Like those artists, Tahara has been able to translate his core interests to different domains. He now finds himself heading more and more in a direction that does not define him solely as a photographer. His installations of luminescent work in the city landscape are totally linked to his core interests, even though they do not directly use the medium of photography. In the last several years he has essentially conceived *in situ* installations, which integrate his photography on glass, stone, or metal—without them becoming an end in and of themselves.

Keiichi Tahara considers himself an autodidactic photographer, using photography as a means to an end. Finding himself quickly frustrated by the conventional photographic world of paper prints, which he found limiting, Tahara turned toward an earlier form of photographic substrate—the glass plate. He found that the images he was interested in lent themselves more to transparency. He liked the synthesis of image and presentation, where the interaction of the image with light became possible. These initial studies led him to experiment and work with materials that are not in and of themselves transparent, but from which light can radiate, such as aluminum, steel, even stone—all coupled with silver photographic emulsion. After his work with pure transparency, he wanted to look at the memory of light through the effect of these different materials.

Constantly researching and exploring the quality of light in his environment, Tahara finds that it isn't photography in and of itself that interests him, but the material traces of light that he is able to translate by using the medium of photography. His first pieces *(Environnement* or *Fenêtre)* were attempts at translating the effects of the passing of light. These installations have grown increasingly more complex as his mastery of materials has developed.

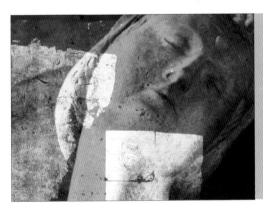

Emulsion and Light

Through his endless research and interest in the nature and quality of light, Tahara couples liquid emulsion with a variety of materials that modify and extend his perception of that light. Working from 24 by 36 mm negatives (35mm film), which he develops traditionally, Tahara uses a conventional enlarger to transfer the images to the emulsion coated onto the substrate he has chosen. After processing, the photos used in his outdoor installations are protected with an anti-UV varnish.

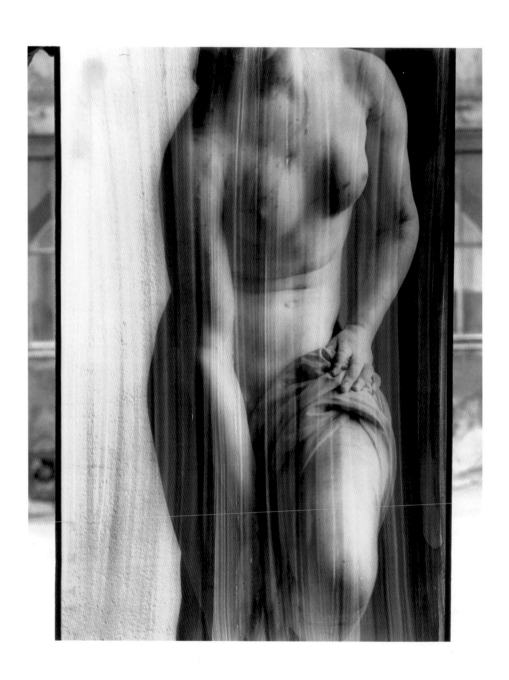

**Installation for Chateau
Beychevelle (detail)**

29 1/2" x 19 1/2"
(75 cm x 50 cm)
Silver on glass, steel base

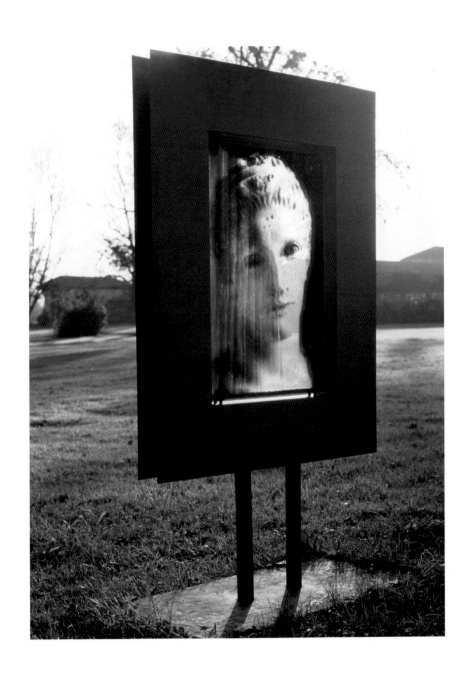

Photograph on Glass

35 1/2" x 51"
(90 cm x 30 cm)
Silver on glass, steel base

Untitled

41 1/2" x 40 1/2"

(105 cm x 103 cm)

Silver on glass, gold leaf

Untitled

31 1/2" x 23 1/2"
(80 cm x 60 cm)
Silver on glass, gold leaf

fragile truth

Tim Pershing

background and influences

Tim Pershing was born in Puerto Rico, and as a young boy would construct sculptures and altars from materials around his home. Although he considered himself a sculptor in high school, his best friend was a photographer and he found himself spending many hours in the friend's darkroom as he worked. Even so, he did not start making photographs until he attended the American College in Paris.

Clearly, his constructions and still lifes come from his sculptural background. Describing himself as a found-object kind of person, he was thrilled when his wife had a truckload of junk, with a red ribbon tied around it, delivered to their backyard for his thirtieth birthday. Much influenced by Joseph Cornell and minimalist sculptor/painter Lawrence Wolhandler (a teacher in Paris who used rough materials), Pershing places great importance on small details. He says, "When you look at my work up close there are little things, small details that carry a lot of importance for me: individual nails, individual lines, breaks in the wood, cracks in the glass, touches of color, all of which come out of my sculptural background."

Although he worked with the silver print in the late seventies and attended the School of Visual Arts in New York for animation, he ended up in the film world, working on major Hollywood motion pictures—art films such as *Mississippi Masala,* and with directors such as John Sayles.

It was Pershing's film connections that sparked his interest in visiting Bosnia. A director friend, who had been to Sarajevo on a UN tour, described its atmosphere so powerfully that Pershing decided to go there himself. His first trip to Bosnia was purely as an artist, but for the second and third trips he returned as both journalist (doing much writing and photographing) and artist. Both "Rose of Sarajevo" and "Three Brothers" were shot during the second and third trips in 1994 and 1995. He notes, ". . . artistically, and in poetry, there was such a defiance of the war going on there, especially in the early years. It was an unbelievable human expression." It is this very human expression that forms the basis for much of his recent work.

Using a variety of discarded and disintegrating materials, Pershing does not make a photograph as much as he plays magician, with the image coalescing from detritus connected conceptually to the experience he wants to convey. Earlier, he was concerned with the immediacy of his materials; and while this is still important in the Bosnia work, Pershing believes his experiences there moved him toward giving his images greater permanence. The work became very personal, and he began to feel it necessary—for both the work itself and the message he was trying to convey—to work harder at arresting some of the decay. "Three Brothers," created with three separate layers of photo emulsion on a bent and rusted refrigerator door—the rust preventing the emulsified image from registering in that area—reminded him of his own brothers and of himself; and so he took care to seal and preserve the entire piece. The "Rose of Sarajevo" box, built using old pallet wood, glass, glazing compound, shellac, spackle, and various pigments, is essentially a hinged case held together with what appears to be the roughest of materials, although it is in fact quite stable.

Many of Pershing's pieces can be viewed without having to know anything about the subject. A second level of the work involves the job of communicating content, at least to provoke the viewer's desire to know more. Whether the viewer is aware of the Bosnia connection or not, Pershing's combination of images and materials conveys the fragility of life in a profound and powerful way. "Perhaps," he says, "in extending the images in the way I do, I draw the viewer away from seeing the image solely as fact, and direct them to what I see as the truth."

Controlled Decay

The massive scale of Pershing's work often creates its own problems. Using cement and plaster results in pieces that can become enormously heavy—even small ones. As rusting nails cannot be trusted to remain strong enough to hold a work together, hidden fastening devices must be engineered into the piece without being seen. Arresting the decay of the construction (or allowing the decay to continue in a controlled way) must also be resolved for each of the materials used. Cracked and broken glass, for example, must be preserved. This dichotomy of maintaining the archival nature of a work while creating the illusion of its transitory nature—its history and place in the field of time—is daunting.

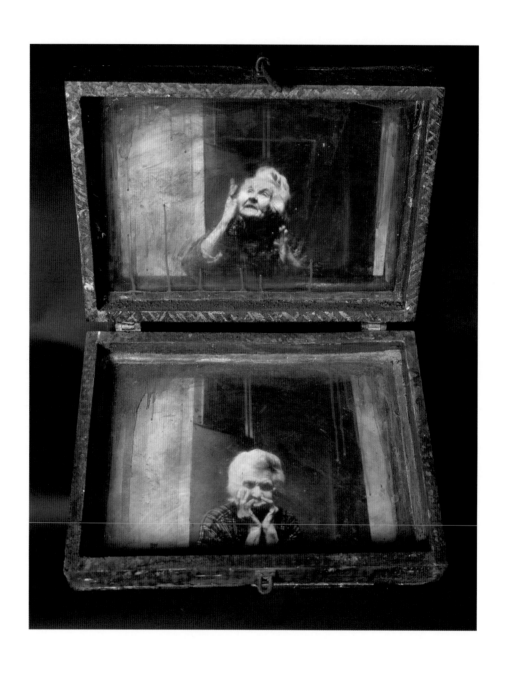

Rose of Sarajevo

3' x 2' x 4'
(.9 m x .6 m x 1.2 m)
Mixed media with silver
gelatin print

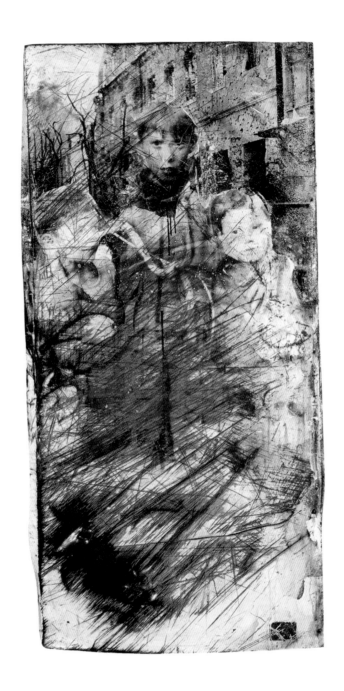

Three Brothers

5' x 30" x 4"
(1.5 m x 76 cm x 10 cm)
Mixed media and liquid
emulsion

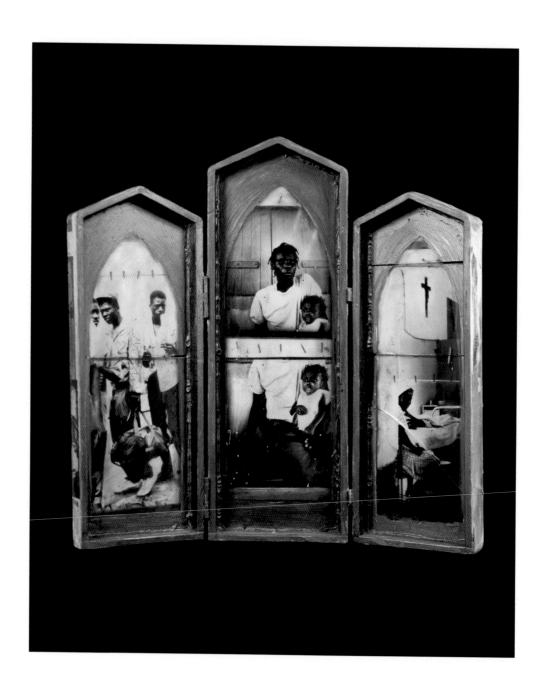

Black Madonna #2

3' x 3' x 5" (.9 m x .9 m x 13 cm)

Mixed media with silver gelatin print

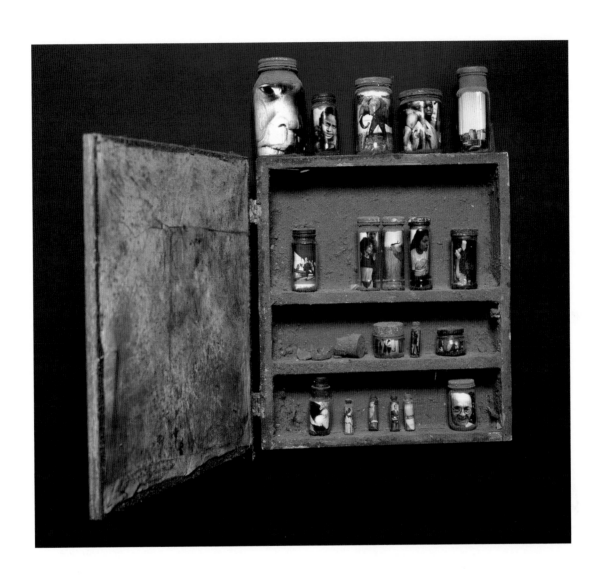

Memory Chest

3' x 2' x 6"
(.9 m x .6 m x 15 cm)
Mixed media with silver
gelatin print

THE EXTENDED IMAGE

The Musical Lament
Judy Natal

The frame. The photograph. The image. Looking through a camera's viewfinder, one views the world through an artificial square or rectangle that requires us to select. Photographers, of course, become adept at selecting just the right moment, just the right frame of that three-dimensional, full-color maelstrom that surrounds us in time and space. Nevertheless, for some, that single slice is not enough. They feel it necessary to convey something beyond that which the single frame documents. It may be a desire to print several frames together, the addition of color to amplify an image's emotional content, or the choice of less traditional printing materials—all can open new ways to make images more personal and expressive.

Internal Journal Series
E. E. Smith

Untitled
Jerry Uelsmann

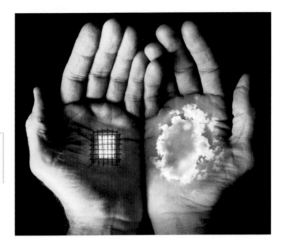

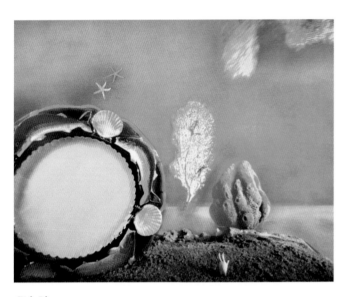

Fish Plate
Bea Nettles

tintypes from a bygone era—object/images that reveal a humanness difficult to deny. Almost in counterpoint, the synthetic gum bichromates of Bea Nettles offer a delightful doorway to a magical, childlike garden. All of them offer us images that represent a clear, personal, and engaging aesthetic.

This section offers the work of several photographers for whom a straight photograph is not enough; for whom the unmanipulated silver or color print, in its economy, does not convey the full richness they wish to reveal. Jerry Uelsmann, recognized master of multiple-image photography, seamlessly blends new realities in the darkroom to challenge our preconceptions and expectations. Judy Natal extends her images from photographic emulsion to ink on paper through photogravure, recombining photographs in powerful, metaphoric collages. Dan Estabrook evokes ruined

Untitled Twins (Joined)
Dan Estabrook

new realities

Jerry Uelsmann

background and influences

By 1960, when Jerry Uelsmann was in graduate school, various people had already experimented with multiple-image photography, but none had taken it to the levels Uelsmann would eventually achieve. It was about this time that his criticism of an Arthur Siegal photograph of a nude superimposed on a highway led him to experiment with similar manipulative techniques—and do them better. In some quarters, this form of postvisualization was considered a challenge to the straight photography of the time, and some galleries did not even consider his images photographs. In the years since, of course, his images have helped reshape the very nature and definition of what constitutes photographic imagery.

While Uelsmann's images involve a certain amount of previsualization, the work only begins there. His initial vision is modified through a spontaneous and often surprising dialogue with the process. "My contact sheets," he notes, "become a kind of visual diary of all the things I have seen and experienced with my camera. They contain the seeds from which my images grow. Before entering the darkroom, I ponder these sheets, seeking fresh and innovative juxtapositions that expand the possibilities of the initial subject matter."

Uelsmann's mythology creates a world where iconographic representation takes on new visual form and the power of empirical reality; it allows him to restate, in his own terms, the portions of our collective unconscious that we share through dreams and the mythic revelations of disparate religions and cultures. This is not to imply that his images and myths relate directly to the myths we know in narrative form. Though they create associations for us, they are primarily visual, and stunningly enigmatic.

Attempts to read his photographs often miss the point. If one of the key differences between a dream and reality is continuity in time, Uelsmann's images seem to exist as excerpts from dreams, given continuity as isolated fragments torn from the dreamer.

For Jerry Uelsmann, work is not random or based on whether or not he feels particularly creative at a given moment; it is a regularly scheduled activity built into his life. Using a variety of masking techniques—sometimes masking just below the enlarger lens, sometimes at the paper easel itself—he is able to combine several negatives in a seamless blending of realities.

Uelsmann's work in the darkroom is a process of discovery, which begins with a review of contact sheets to select a starting point for his work session. Once work begins, he allows the images to lead him on a quest for combinations that might inspire or surprise him. Often the images go through a series of changes as the combinations he selects either work or suggest other, perhaps more successful image relationships. The image he settles on is often totally different from the concept he started with.

Building on the traditional concept of the photograph as a window on the world, he creates a visual structure in which we experience the unfolding of a growing iconographic drama. His images invest the viewer with a magical window to a reality where dream finds an anchor. He challenges the viewer, offering unlikely juxtapositions of object and environment, spatial shifts we know cannot exist but believe anyway, and a seeming defiance of natural laws that somehow feels right.

The Blend

Working in a darkroom with eight enlargers, Uelsmann is able to align different negatives and easels so that he can simply move the photographic paper from one machine to the next, and so make the process a bit easier. He tests the exposure for each negative so that the tonal areas he wishes to blend will match in the final print.

While he occasionally photographs objects against different backgrounds—a light table or a plain white background—to make it easier for him to add the objects to the print without excessive masking, most of his negatives are taken in a more or less conventional manner.

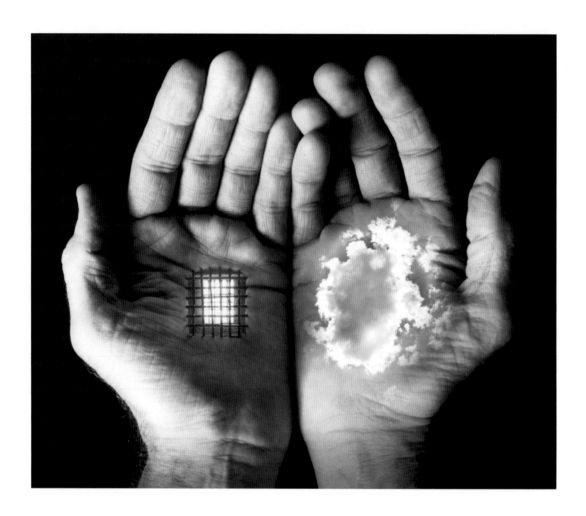

Untitled

16" x 20" (41 cm x 51 cm)
Silver gelatin print

Untitled

20" x 16" (51 cm x 41 cm)
Silver gelatin print

Untitled

20" x 16" (51 cm x 41 cm)

Silver gelatin print

Untitled

16" x 20" (41 cm x 51 cm)
Silver gelatin print

persistence
of memory

E. E. Smith

background and influences

Since she first began taking photographs almost twenty-five years ago, E. E. Smith has been persistently investigating alternative photographic methods. While her early work utilized the more subtle monochromatic processes such as cyanotype, Van Dyke brown, and platinum, she began to incorporate color by using gum bichromate printing and more recently, the oil print, which she has used almost exclusively since 1993.

In college, working with the standard silver gelatin print, Smith found ways to subvert viewers' expectations of the photograph by printing large-scale black and white images, and exhibiting them in installations with her sculpture. Sensing that people had been saturated with images from the media and no longer devoted the necessary time or energy to really look at traditional photographs, she began to use a number of nineteenth-century hand-applied emulsions so that her work would "read" more like a painting and less like a photograph. In this way, Smith felt that viewers could move beyond the notion of photography as documentation or objective truth, perhaps because her photographs seemed more personal and subjective—more like paintings.

Smith's work reflects her interest in the ways that memory—collective memory, not necessarily personal memory—affects history. She photographs everyday objects and scenes of middle-class America to evoke the nostalgia of the American Dream while at the same time demonstrating that it is a constructed myth. With intentional blurring, soft fading colors, and the exploitation of grain and variation in scale, her images appear almost dreamlike; yet the banality of their subject matter belies any sentimentality.

This particular body of work focuses on the interiors of rural Kentucky—a farmhouse that has been shared by three generations of women in Smith's immediate family, and her mother's modern brick house. She spent summers at the farm as a child, and continues to spend several months a year there, where she now maintains a studio.

E. E. Smith first read about oil printing in *Keepers of the Light,* a book chronicling the history of various photographic methods. Although she has adapted the process slightly, she found oil printing particularly appealing; it gave her strong rich blacks and the ability to use color selectively. The oil print also appeals to her because of the subtle, subjective quality it brings to her work.

Smith begins by exposing a negative onto Kodalith (high contrast) film through nonglare glass to achieve a grainy, almost mezzotint-like negative. As this is a contact printing process, the negative must be as large as the print she intends to work with—in her case 30" by 22" (76 cm by 56 cm). She then applies by hand three layers of gelatin onto watercolor paper. After the paper is dry, the gelatin surface is coated with a solution of ammonium dichromate, which makes the paper light sensitive. The enlarged negative is then placed in contact with the sensitized paper and exposed to strong actinic light. The paper is washed and air-dried. In the areas that received exposure the gelatin hardens; in the areas that received no light, the dichromate washes away. The paper is again soaked in water and colored lithography and etching inks are dabbed on with a brush. The area where the emulsion has been hardened by exposure readily accepts ink; the area that received no light, and has become swollen with water, rejects the ink.

Much of Smith's work is composed of four individual sections, each 30" by 22" (76 cm by 56 cm), which make a final work measuring 60" by 44" (152 cm by 112 cm). The sections are not always in perfect registration. This not only emphasizes the hand-applied nature of the medium, but contributes to the "otherworldly" ambiance of the images.

Expanding Grain

In enlarging her negatives, Smith expands the grain to create the atmospheric quality that alludes to the sense of memory and time removed she attempts to convey. It is the extreme enlargement of the image, along with the exploitation of the inherent textural pattern of the nonglare glass she sometimes prints through, that gives her a type of halftone negative particularly suited to oil printing.

As Smith prints, she controls the density of the color by the number of layers she chooses to build up on the paper. It is this control of color that offers her the subtle and engaging qualities she brings to her work.

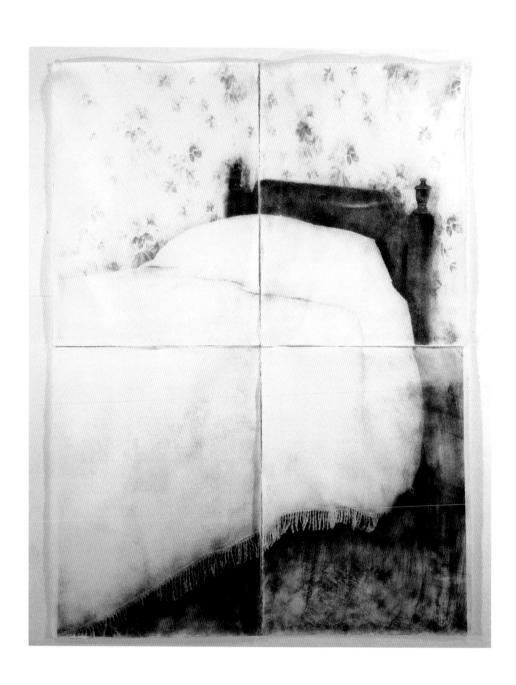

Interior Journal Series

60" x 44" (152 cm x 112 cm)

Oil print

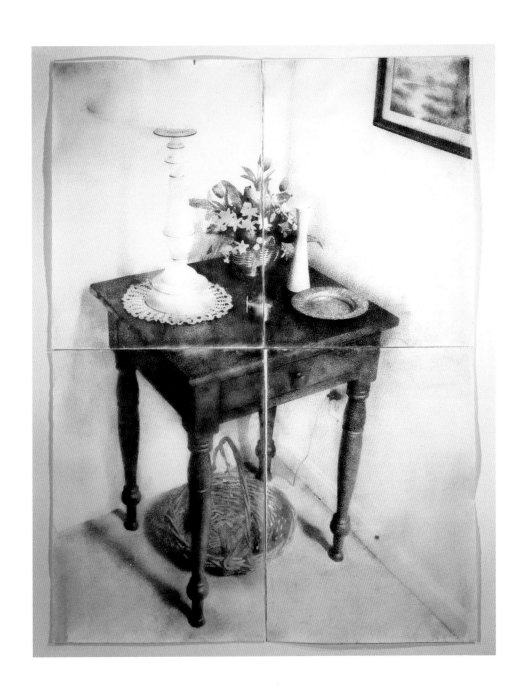

Interior Journal Series

60" x 44" (152 cm x 112 cm)
Oil print

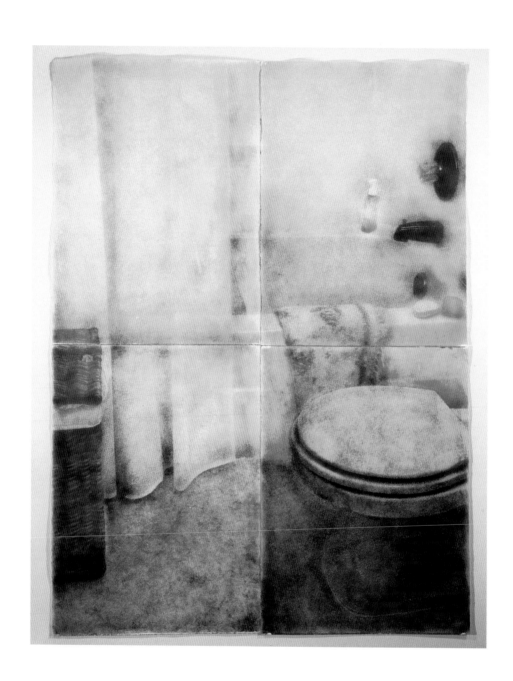

Interior Journal Series

60" x 44" (152 cm x 112 cm)
Oil print

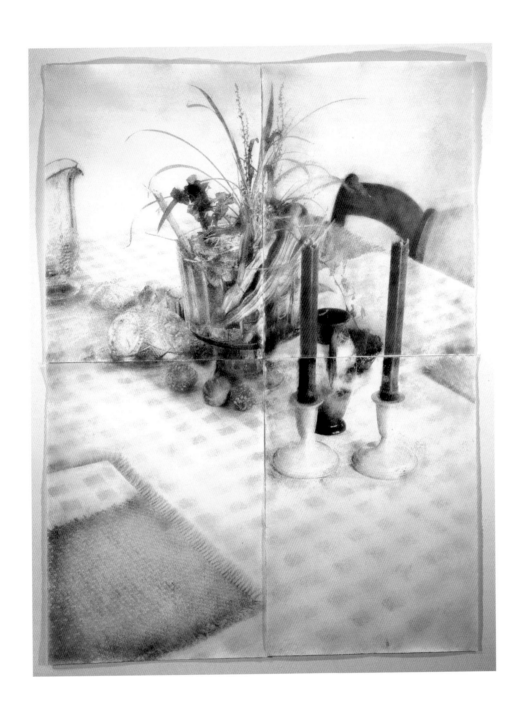

Interior Journal Series

60" x 44" (152 cm x 112 cm)

Oil print

printmaking collage

Judy Natal

background and influences

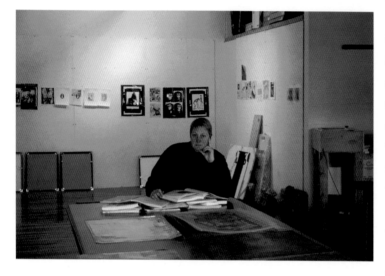

Because of a high-school crush on a boy who happened to be a photographer, Judy Natal bought her first camera, sure that this would win his heart. The boy soon faded in importance, but Natal's interest in photography was born. Later, while studying theatrical lighting design at the University of Kansas in Lawrence, she switched to photography after realizing that she was not a "collaborative" person.

However, it was in a two-dimensional design course—part of her theatre requirements—that she met one of the first influences on her artistic life: her "white-haired design teacher who asked all the questions you couldn't answer." Her interest and curiosity were piqued, and she eventually became an art major, studying photography and printmaking. James Enyeart, the photo curator at the university, became her mentor. She was also given the opportunity to participate in printing and organizing the nineteenth-century glass plate negatives owned by Lawrence's Spencer Museum—a collection of some forty-thousand items.

Natal's work with photogravure started as a fascination with images in the early twentieth-century periodical, *Camerawork*. She was already working in photo etching and printmaking, and was hired by Enyeart to reproduce his work in photogavure. With an undergraduate research grant to buy materials, she began what she thought would be "a piece of cake" to learn. Two years later, she finally felt she was beginning to get a handle on the art of photogravure.

At the Rochester Institute of Technology she met Greg Taylor, who was completing his thesis in photogravure at the Visual Studies Workshop. Taylor was knowledgeable in his subject and willing to share his expertise, and they became friends, working together and sharing darkroom space in Rochester until she finished her MFA. Another major influence at RIT was Bea Nettles, for whom Natal was a graduate assistant. Nettles taught her that "breaking traditions was acceptable," and gave her guidance on artists' survival skills in the real world— lessons that proved invaluable. Natal now teaches at Columbia College in Chicago.

Photogravure is a nineteenth-century tone-for-tone reproduction process in which a sensitized, exposed, and etched copper plate is evenly inked, then wiped clean to remove the ink from the surface of the plate while leaving ink in the etched crevices. A uniformly dampened paper is then laid over the metal plate and ink from the plate is forced from the grooves onto the paper by the pressure of the press. Photogravure attracted Natal because she saw it as a way to construct collages that would print as a unified image. As it requires a film positive the same size as the intended print, she must create a collage of separate film positives—sometimes two, sometimes forty or fifty—all made to be the final size required by the print. These individual positives are delicately taped together to form a single, unified film positive, which she feels is more precious to her than the original negatives.

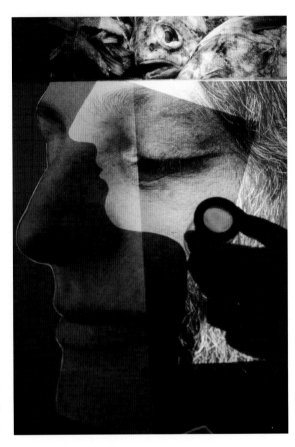

To create her film positives, Natal has used everything from photocopied paper negatives, mylar, ortho litho film developed in Dektol, fine-grain positive—whatever works best to achieve her aesthetic goals. Anything that can be exposed and developed to fall within a certain range of density is considered suitable.

Natal feels strongly that everything in the process contributes to the image, including the paper support, which activates the image. She feels that artists should first develop their technical skill—a lack of technical knowledge should not interfere with being able to interpret ideas visually. In keeping with that, artists should also realize the process is only the vessel that contains the idea. "Process without content," she says, "is nothing."

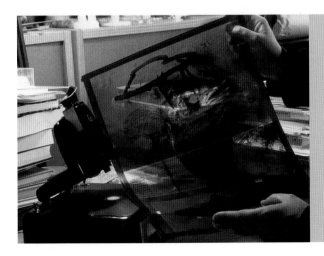

Matching Density

To create a consistent positive, each image must be carefully exposed and developed to have a density range of .5 to 1.5 as measured on a densitometer. If each positive falls within this range, the collage will print seamlessly, with the same tonal range for each positive, in the final gravure. The transparent tape Natal uses to hold the separate negatives together has about the same base density as film, so it disappears in the final print.

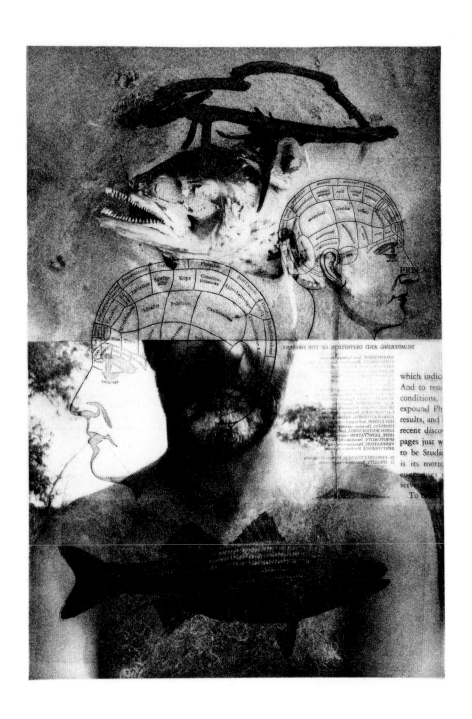

The Musical Lament

30" x 24" (76 cm x 61 cm)
Photogravure

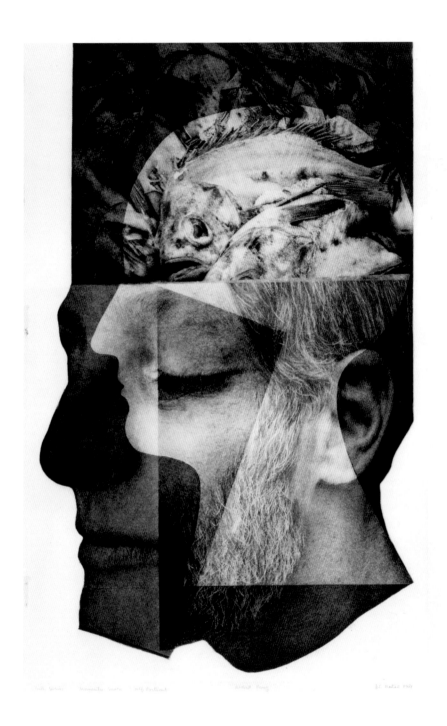

**Memento Mori
(Self-Portrait)**

30" x 24" (76 cm x 61 cm)
Photogravure

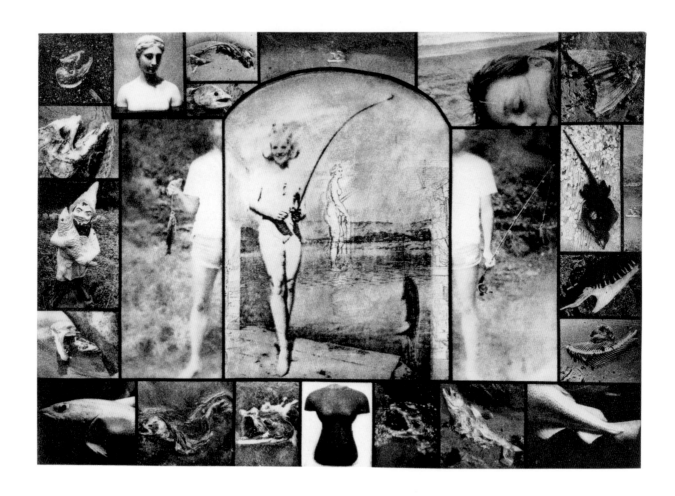

Analysis of Beauty

24" x 30" (61 cm x 76 cm)

Photogravure

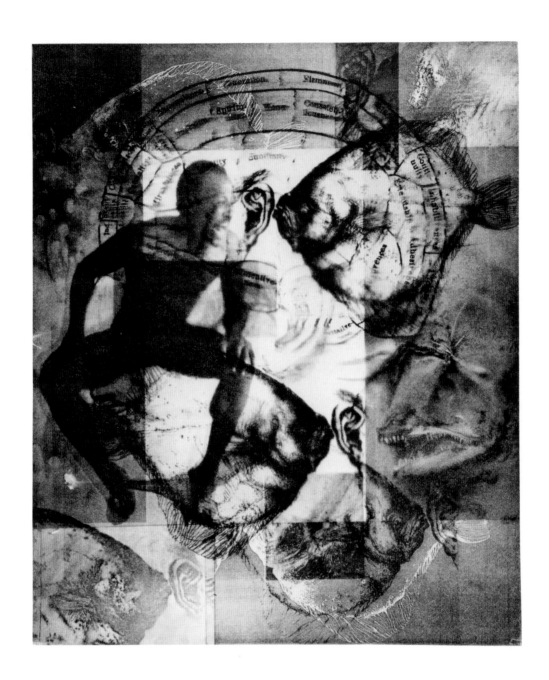

The Conversation

30" x 24" (76 cm x 61 cm)
Photogravure

the personal artifact

Dan Estabrook

background and influences

Dan Estabrook grew up knowing he wanted to be an artist. While his early work was primarily in the area of drawing and printmaking, he fell into a more serious relationship with photography as he entered Harvard—luckily having met Christopher James, who with his background as a painter had different ideas about what photography was and could be. This was fortunate for Estabrook; a more straightforward approach to photography might not have engaged him. Under James's guidance, he was soon introduced to alternative processes. It was 1986 and Estabrook felt he had found a place where he could investigate the concepts he was interested in.

When Estabrook went on to graduate school with Bea Nettles at the University of Illinois, he found reinforcement for the ideas introduced by James. At that point he felt it was no longer necessary to be taught specific technique; trial and error became liberating, freeing him to experiment and take his work to new levels.

Since completing his graduate studies, Estabrook has worked as an art director, mostly dealing with sets and props for films. His interest in this area started during his student days, working with a close friend to make small films and music videos. He completed his first feature film about a year and a half ago. As even a simple thirty-second commercial can take up to fifty people and extensive equipment to complete, Estabrook appreciates the more solitary activity of creating his own worlds—in which he can work alone, pleasing no one but himself.

As an undergraduate, Estabrook worked with more conventional, hand-applied emulsions, but later decided to try something more complex—large, three-dimensional gum bichromate images, printed off register and viewed with special 3-D glasses. This project caused him to reexamine what his love for alternative processes was really all about—a more visual, tactile presentation, an appreciation of the photograph as object.

When he looked at his own collection of tintypes—the kinds of things that inspired him—he decided to try some tintypes of his own. He noticed that he had a large collection of infant photographs, both baptismal and funereal. He began to think about the photograph as holding some part of the human "soul." He wanted to make photographs that captured human essence in paper or tin or glass—realizing of course that the human essence he was trying to capture was his own.

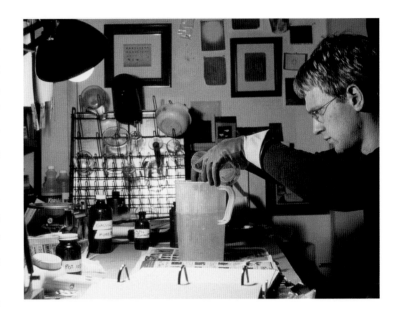

This interest in the photograph as an actual object has sustained him. Tintypes became a focus for him—they had thickness, and weight, and they were physical objects representing very small, personal things. Even his early paper prints were likely to be wrinkled or curled or ripped or creased—anything that might bring the viewer's attention to the image as an object.

Estabrook's work is essentially a contradiction, one he describes as an attempt to create his own found objects and then scrape away to find what is underneath. His concern is not for historical accuracy, and he makes no real attempt to produce historically correct tintypes. Rather than collodion on tin, he uses a modern dry plate process. His real interest is the dialogue created between the photograph as image and the photograph as object.

The Imperfect Object

Estabrook feels the need to work with his hands, like an artisan or craftsperson—to do something physically to an image before he can call it his own. His desire to create an image that is also an object—to tear it, tone it, or crease it—is a desire to indicate both the passage of time and the fact that we are dealing with a *representation* of reality, not reality itself.

Though he finds that some of the images he builds in his studio are absurdly complex and would be much faster to assemble on a computer, the idea does not work for him. He feels that digital photographs are essentially drawings masquerading as photographs, and that his own work is the other way around—photographs masquerading as drawings.

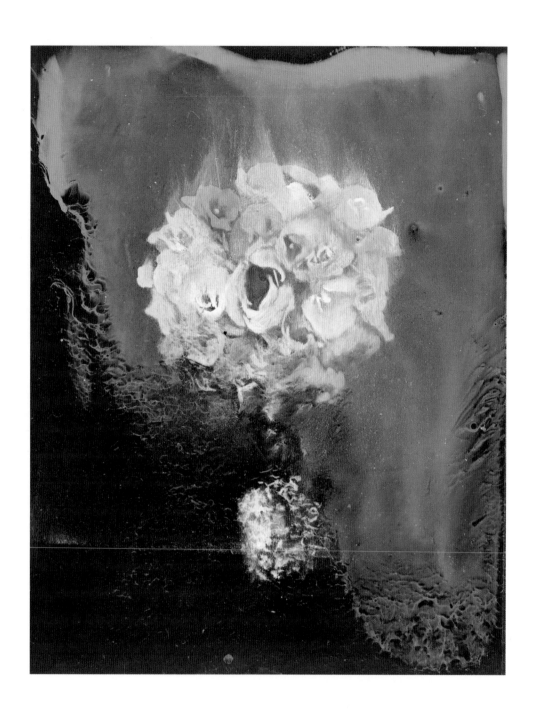

Flowers, Second Version

5" x 4" (13 cm x 10 cm)

Ambrotype, oil paint

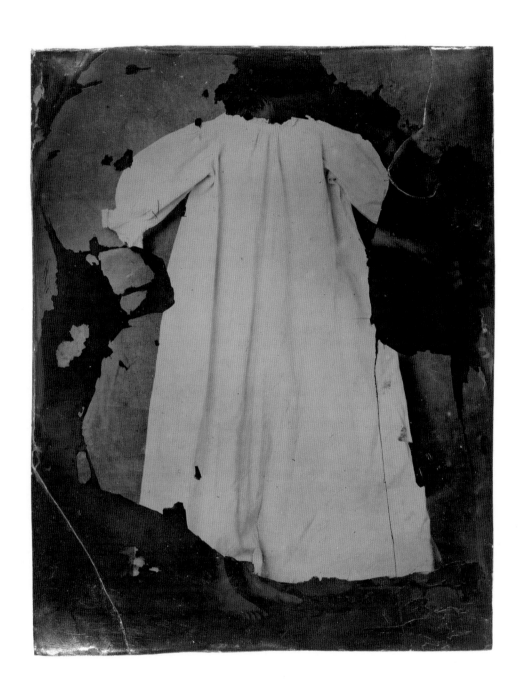

Untitled Self-Portrait

10" x 8" (25 cm x 20 cm)

Tintype

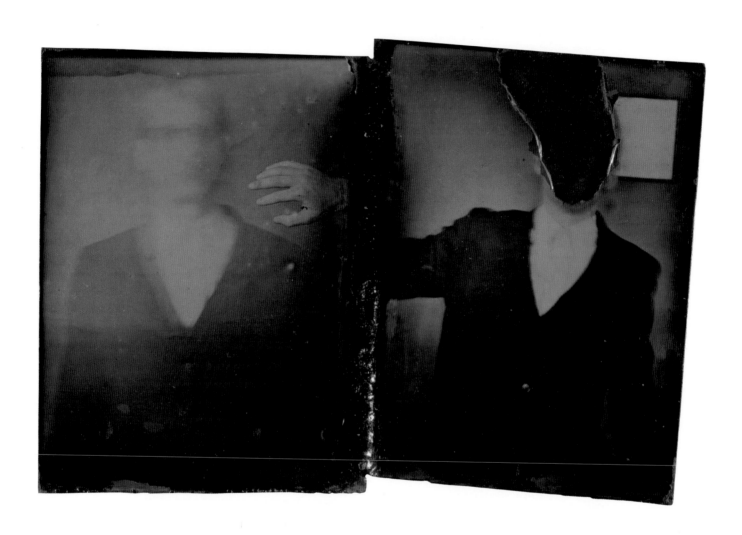

Untitled Twins (Joined)

10" x 15" (25 cm x 38 cm)

Tintype on steel

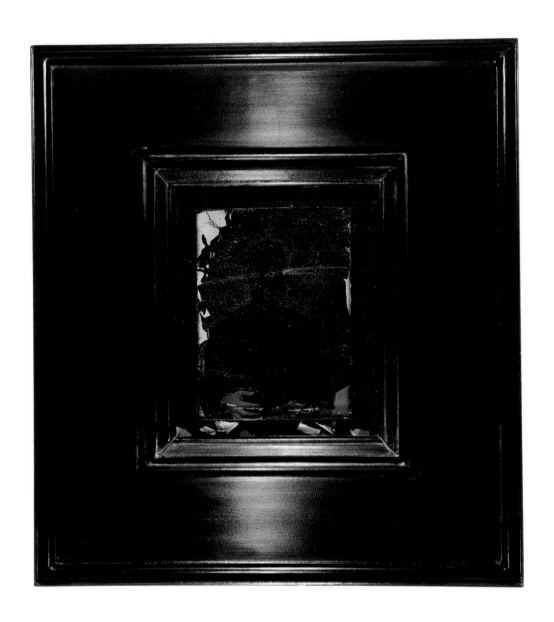

Untitled Portrait

5 1/2" x 3 1/2"
(14 cm x 9 cm)
Tintype, ink

the magic landscape

Bea Nettles

background and influences

One of the great pioneers of the non-silver processes of photography, Bea Nettles met great resistance in graduate school due to her experimental approaches and "female" imagery, neither of which were very popular at this time of male-dominated art departments. Banned from her graduate-school darkroom in the early 1970s, at a time when she was using a sewing machine to combine photographs and paintings on fabric, she resorted to a nearby basement where she had to use heaters under the trays to keep them from freezing. Her persistence paid off; by the year's end two of her works were hanging in The Museum of Modern Art in New York in a show called "Photography into Sculpture." Numerous one-person shows followed, as did offers to teach. (Ironically, Nettles is now chairman of the same art department that once scoffed at her.)

In the early 1970s, many of the techniques we know today were either not in existence or not published in an up-to-date workable form. Nettles found that many artists were extremely secretive about their working methods. Others, fortunately, were more open. Nettles was much inspired and influenced by Betty Hahn, who reintroduced an older gum bichromate process; and by Robert Fichter, her undergraduate college teacher, known for his work in cyanotype. After many years of investigating, experimenting, and adapting various non-silver techniques, Nettles's biggest contribution, perhaps, is that she passionately taught these methods to others—through classes, workshops, and books.

In 1977 Nettles published *Breaking the Rules: A Photo Media Cookbook*, which continues to inspire students and professionals. It chronicles the working methods of many of the non-silver processes, most of which she has incorporated into her work, and many of which she helped develop and promote.

Books have always been important tools for her, both in her teaching and in her creative work. Having produced over twenty books, she considers them an important alternative to gallery shows because of their availability to a larger and more varied audience. She has received numerous grants, to work on her own books and to obtain the desktop publishing technology that has made bookmaking accessible to her.

Reflecting her interest in female mythology and in issues of being a woman, Nettles's work has been primarily autobiographical. This particular series deals with her concerns as a new mother: gender issues, early childhood as it relates to character formation, sibling rivalry, and the stresses and responsibilities of motherhood in this generation and culture.

Inspired by the chaos she lived with as mother of a preschooler and infant—toys, clothes, fantasy characters—Nettles produced this series entitled "Close to Home." Because she was teaching full-time and often house-bound, Nettles needed a photographic method she could work at in short spurts and multiple sessions. Created during her children's nap times, this series was produced and printed in the backyard or basement—literally close to home. These still-life images often appear as a child might see or imagine them. Taken at a low angle, based in fantasy, with odd colors and juxtapositions, the series was produced with a pinhole camera that contributed to their "otherworldly" perspective.

Contributing further to the fantasy effect was Nettles's printing technique, a commercial synthetic gum bichromate process that Nettles helped modify and promote. Using light-sensitive colors consisting of watercolor pigment, gum arabic, and ammonium bichromate solutions, Nettles buffed these colors onto a vinyl sheet one color at a time, exposing the sheet to a strong light source while in contact with the pinhole negative. When rinsed, the unexposed areas washed off; the exposed areas left an image. Building up the colors this way, Nettles produced strange and wonderful combinations that added to the surreal quality.

Through the Pinhole

To make the pinhole for the camera lens for the "Close to Home" series, Nettles used a sewing needle to puncture an aluminum pie plate, and then sanded it. For the camera she made a large foamcore box with a removable back, and painted the inside (including the pinhole) black. A sliding door across the pinhole served as shutter (removable black tape also works). Direct sun or quartz lights illuminated the set. Using long exposures of often five to eight minutes, Nettles opened the shutter to expose ortho film inside the camera. She then developed the film in continuous-tone developer, producing a contact-size negative, in this case 16" by 20" (41 cm by 51 cm).

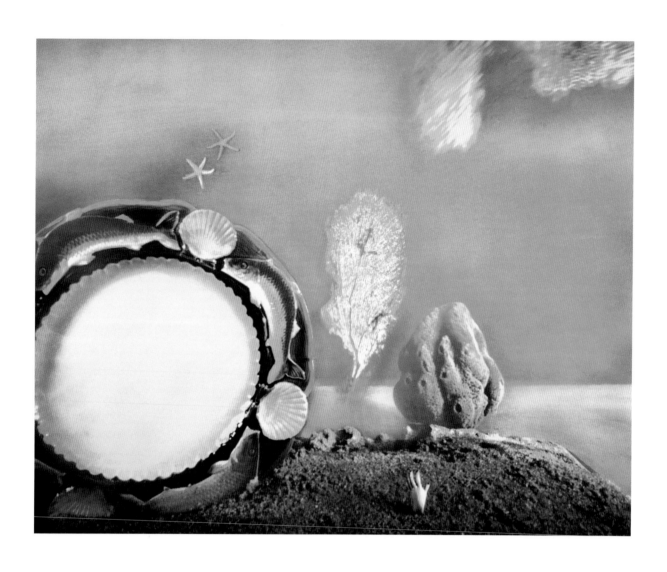

Fish Plate

16" x 20" (41 cm x 51 cm)

Synthetic gum bichromate on vinyl

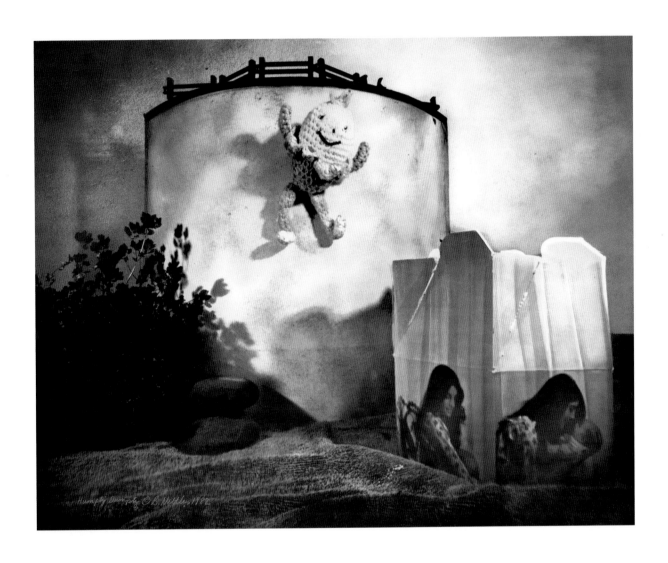

Humpty Dumpty

16" x 20" (41 cm x 51 cm)
Synthetic gum bichromate
on vinyl

Bird Scissors

16" x 20" (41 cm x 51 cm)

Synthetic gum bichromate on vinyl

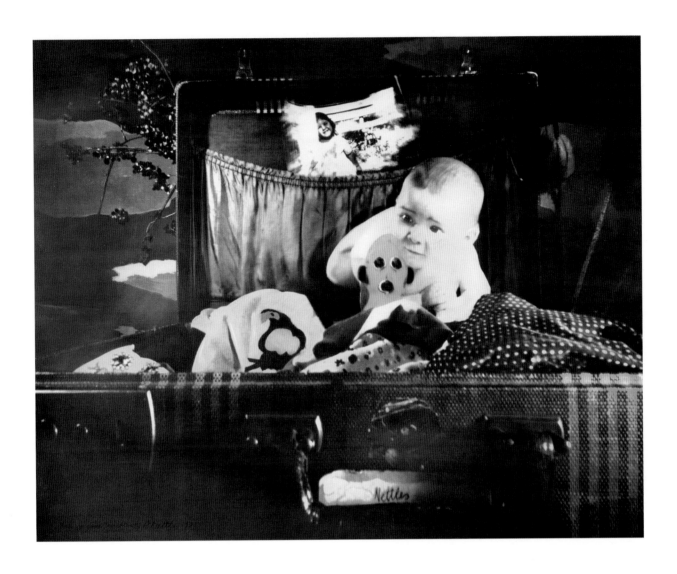

**Pack Up Your
Troubles**

16" x 20" (41 cm x 51 cm)
Synthetic gum bichromate
on vinyl

THE DIGITAL IMAGE

The magic of the digital image is both engaging and addictive. New worlds, new realities open to us. Dreams take on substance. The impossible becomes commonplace; artist/photographers become demigods fashioning the world to suit their visions. Of course, there are still the more mundane yet important uses. Color balance can still be corrected. Portions of an image felt to be confusing or outside a composition's scope can still be retouched or eliminated. The focus here, however, is on the photographer using digital magic as a creative tool, the photographer intent on creating realities we may not collectively perceive.

The Androgyn Presented as a Token of Love
John Reuter

Game Edge
Olivia Parker

Easter Sunday
Maggie Taylor

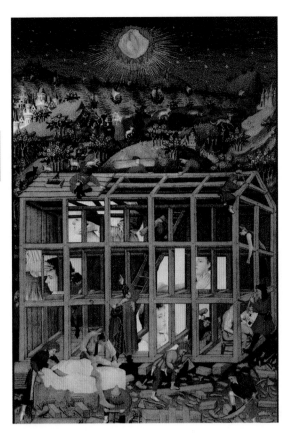

Building
Joyce Neimanas

Initially the province of retouchers and the publishing world, the digital image has become a staple of many fine art photographers. Many colleges and universities now offer programs in digital media. The challenge remains to define a language that digital imaging can claim as its own. How do photographers engaging the digital image create work that moves beyond being defined by process? How can artists create images that involve viewers beyond considerations of filters and techniques?

The images of experienced photographers may begin to answer this question. Olivia Parker, well known for her still life photographs, offers magical tableaus that move us beyond questions of technique. The same can be said of Maggie Taylor's whimsical fantasy images, often created without the intervention of a conventional camera. John Reuter, known for his work with Polaroid, has found a way to transfer his skill to digital images, and Joyce Neimanas's evocative, collage-like constructions evoke a printmaking aesthetic in their use of this relatively new medium.

Olivia Parker

background and influences

When Olivia Parker was about six years old, her parents gave her a box brownie camera. This serendipitous introduction to photography, however, was not to bear fruit until many years later. In college she studied art history and then painting, still taking photographs but not too seriously. Through the unfortunate circumstance of a portrait-photographer friend's divorce and subsequent request to store the friend's photographic equipment, she began teaching herself photography. Her trash barrels were soon filled with prints. "My darkroom work is very intuitive, sort of like cooking—a little of this, a little of that."

She soon discovered that she wanted to photograph rather than paint, because she enjoyed the thought process. "Instead of working on one painting for six months, I was able to work on a whole sequence of images. I liked that way of thinking." She could move forward, develop a series of images, and then return to the beginning to reexamine the idea.

More or less anchored to one place while she was raising her children, and a little jealous of friends who were free to travel at will, she began the series of split-toned still life images for which she became so well known. She also found that she could grab time to work while her children were sleeping or playing, to work in short bursts under the skylight in one section of her rambling home. Major exhibitions and grants followed, including one from the Polaroid Corporation, which supplied materials and technicians to assist her as she began to explore the qualities of light that had inspired her earlier constructions. She began to use a split-light technique, which included both daylight from the skylight and incandescent light in the same image.

Starting with fairly primitive software and a scanner acquired in trade for a print, she began to explore digital photography. Five years ago she took her first workshop in Photoshop. An offer followed to be an artist-in-residence at Crimson Tech in Boston, where she got to "play with all the toys."

Initially working with a view camera and fabricating still lifes in a defined and limited space, Parker discovered that these traditional methods had primed her for the computer. In her still lifes she "had been putting things together all along, with the essential ingredient in the photographs being light."

Her opting for the computer was much influenced by a previous, rather painful experiment in cutting up color transparencies and taping them together to create nonexistent objects. Although she liked the results, making 4" by 5" (10 cm by 13 cm) transparencies of all those little pieces of film, then placing them in the enlarger to make an exposure—only to watch them pop apart in the negative carrier—was discouraging to say the least. She soon realized that ideas like these would do better in a digital environment.

Parker finds that one of the advantages of working with a computer is that she can forage through her images, combining them in various ways to form new composites. She is free from the restrictions of photographing in a controlled environment; the world is open to her as a resource.

In the "History of the Real" series, Parker explores the idea of what is real to different people at different times. Parker still plays with the history of still life though, and feels that it has a direct relationship to human beings. "Still life is close to the core of life—food on the table, flowers, with their implications of sex or maybe death. The space of still lifes is very intimate, a place with shelter, next to the objects."

Scanning Resources

Parker uses Photoshop to create her images, using mostly her own photographs. She also uses the scanner as a camera, sometimes placing objects directly on the scanner bed. While she is careful not to infringe on the copyright of work from living artists, she does utilize old etchings, books, maps, etcetera, from before 1850. Most of the final images are IRIS prints from Nash Studios and are produced in limited editions.

Herbivore-Carnivore

24" x 20" (61 cm x 51 cm)

Nash Ink Jet print

Action Toy

24" x 20" (61 cm x 51 cm)

Nash Ink Jet print

Game Edge

21 1/2" x 24" (55 cm x 61 cm)

Nash Ink Jet print

**Still Life with
Soap Bubble**

29" x 20" (74 cm x 51 cm)
Nash Ink Jet print

transition to digital

John Reuter

background and influences

John Reuter has been making photographs since he received his first camera as a high school graduation present. In 1972, as a sociology major at the State University of New York in Geneseo, he started taking photographs for the yearbook and met his first major influence, teacher Michael Terres. Terres introduced him to the concept that the photograph could be a jumping-off point for creating a work of art. This appealed to Reuter, who felt more affinity for painting and manipulative photography than for the straight silver print. In fact, Terres's wife, Reuter's first painting teacher, encouraged him at the outset to integrate photography into his paintings.

In 1975 Reuter chose the University of Iowa for graduate studies—partly because of its atmosphere of aesthetic freedom. In late 1974, he had started working with a Polaroid SX70. The introduction of Polaroid materials to his early work was a revelation. Collage that combined painting and Polaroid materials soon became his major theme. In 1979, because of his expertise with these materials, in particular his use of the Polaroid transfer process, he was offered a position at Polaroid in Boston. Given the option of operating the new 20" by 24" (51 cm by 61 cm) camera and working in Polaroid's research studio, he chose the research studio. Within a year, however, he moved to New York to run the 20" by 24" (51 cm by 61 cm) camera. That was in 1980 and he has been there ever since, working with many of photography's strongest image-makers. Four years after he began operation of the huge camera, he started to see ways in which he could make it work with his own imagery, specifically in creating large-scale, multilayered image transfer pieces.

Reuter describes his work in multilayered terms too—expressionistic, symbolic, romantic. He attempts "to convey an emotion, a gesture, to have an effect" on the viewer. His Catholic upbringing exposed him to religious imagery—usually bad reproductions—from earliest childhood. Traveling in Europe, he was overwhelmed by the power of the actual works in their appropriate environments. It is this tangible, emotional power that Reuter tries to convey through the sheer physicality of color, gesture, and expression his work embodies.

Reuter transfers 4" by 5" (10 cm by 13 cm) images of nudes to a special
SX70 Polaroid film base, then strips away parts of the image, leaving only the
figures on a clear sheet of film with multiple exposures and bubbled-up
emulsion. He then looks for reproductions of old-master paintings to combine
with his images. About one out of thirty attempts succeeds. Once he finds the
right elements, he makes an 8" by 10" (20 cm by 25 cm) transparency of the final
collage, then turns to the 20" by 24" (50 cm by 61 cm) camera to rephotograph
the image. In some cases he breaks the image into nine separate pieces—one
20" by 24" (50 cm by 61 cm) frame for each panel. The result is large—5' by 6'
(1.5 meters by 1.8 meters). After rephotographing, Reuter makes transfers of
each section. The entire nine-panel set is affixed to a wall, reworked, and
mounted on canvas.

Reuter is now working digitally, a gradual transition similar to his
experience with the big Polaroid camera. Through experimentation with
Photoshop, the almost-abandoned collage work was reborn. As software
improved, he realized that "the image on the screen began to have more of a life
for me, rather than thinking of it as merely a prelude to an end product"; he calls
it "the seduction of the screen." Although creating collages onscreen, he was
still producing conventional transparencies and transfers to make the print. A
growing confidence in the new medium, and the realization that information was
being lost in this multistep process, completed his seduction.

Polaroid and Digital Parallels

Reuter does not work with a preconceived product in mind. His
digital work and his Polaroid work both employ similar techniques.
The first step is the gathering of specific backgrounds, figural
elements, and interiors. The creation of layers, either by scanning
various elements and working digitally, or by photographing the
elements and creating an interesting new environment in which to
place a figure, is all-important to both methods. He draws parallels
between working in Polaroid and working digitally—the instant
feedback inherent in both processes allows the artist to work quickly
and make spontaneous decisions.

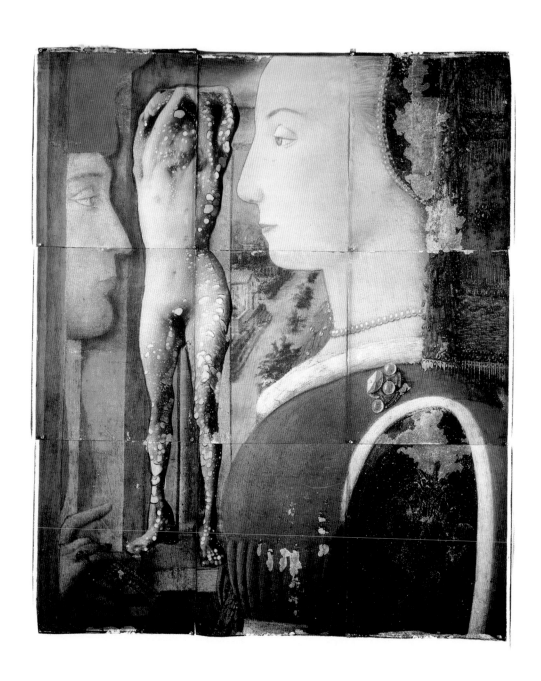

**The Androgyn Presented as a
Token of Love**

6' x 5' (1.8 meters x 1.5 meters)
Polaroid transfer

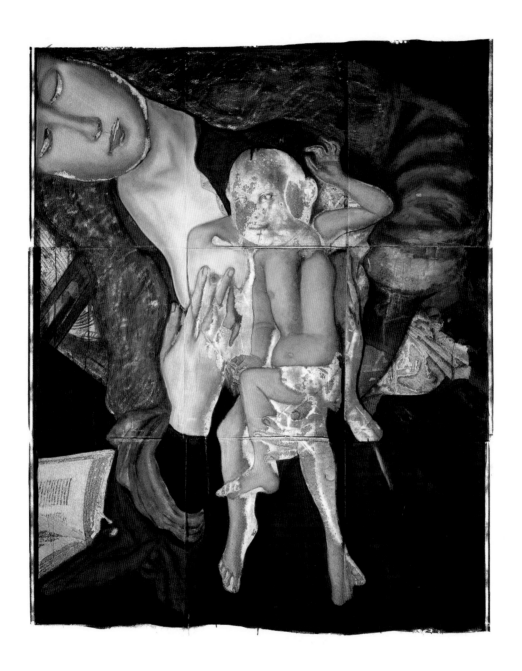

Madonna and Androgyne

6' x 5' (1.8 meters x 1.5 meters)
Polaroid transfer

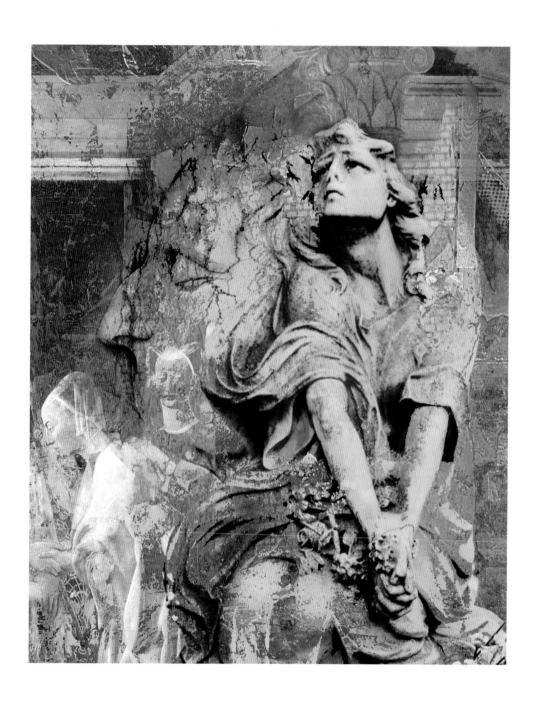

Piero Profile

16" x 12" (41 cm x 30 cm)

IRIS Ink Jet print

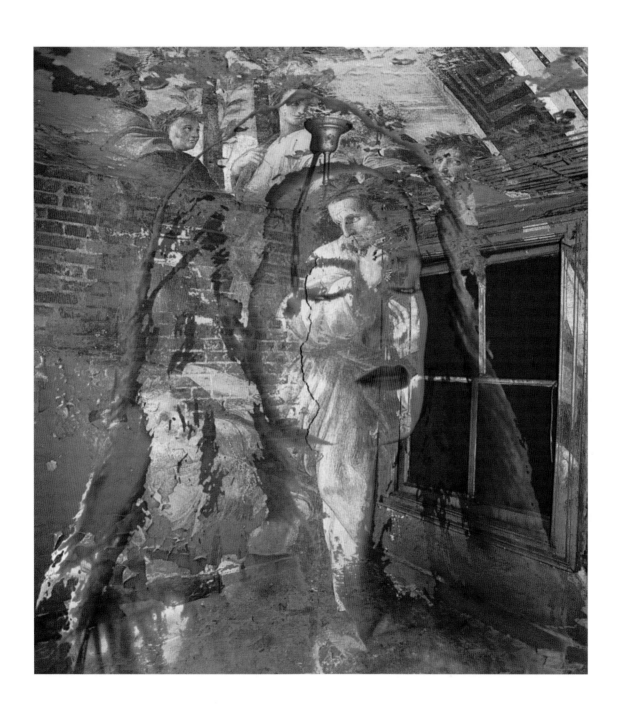

Looking Back

16" x 12" (41 cm x 30 cm)
IRIS Ink Jet print

Joyce Neimanas

background and influences

As an undergraduate art major in painting and education, Neimanas took a variety of courses in different art areas. Some, like weaving, took too long to see the entire image. Painting was better, but blank canvases were too overwhelming. Printmaking was too indirect, and sculpture was challenging but too hard to store. Her mother liked her work in ceramics until she started making nonfunctional pieces with photographs on them. Finally, she realized it was not the media she liked or disliked, but the way she was using them; she was trying to work the materials in traditional ways that clashed with an untraditional aesthetic.

When Neimanas entered graduate school at the Art Institute of Chicago in 1967, she was the first and only student with an emphasis in photography. At the time, SAIC was only one of four graduate programs in the country, and she chose it so that she could attend part time while teaching elementary art.

Perhaps because it was new in the curriculum, perhaps because of the faculty, photography seemed to offer fewer restrictions than other disciplines. In any case, her teachers encouraged her to experiment. Whether creating her own liquid emulsion (which she tried coating on everything imaginable), or enlarging found frames from 8mm films, her work began to grow. A Polaroid SX70 camera bought from a pawn shop—dubbed her potato chip camera because she could never just make one picture—motivated her to create large composite images from many small Polaroid chips, reassembling reality to create the spatial sense she was after. Since receiving her first Macintosh as a grant (one of ten nationally) from the Apple Corporation in 1992—and with it, her introduction to the digital image—she has moved definitively beyond linear forms of image construction.

While the computer controls the creative logic in Neimanas's work, the magic is still in the intuitive shaping and combining of images. Using visual material drawn from contemporary and historical manuals, fashion magazines, and advertising, she references the world not as it exists, but as she deliberately reconfigures it.

The form of the image is critical to the idea Neimanas wishes to project. She recognizes that it is not just input that makes a picture, it is output too. If the colors are wrong—if they are grayed or not saturated—the intensity of the referenced material will not speak her intended irony. Knowing that beautiful hand-torn paper printed with the rich black of an etching is historically meant to seduce the viewer, she pays particular attention to surface, color, and scale.

Unlike many photographs, Neimanas's pictures do not represent a particular moment in life, but they are *about* life—life that is at best confusing and at worst dangerous. They are about those day-to-day activities forming layers of thought that impact on every other next moment. While her work seems visually complex, the idea behind it is simple: the contradictions in our society. She uses comic-book figures as symbols for the heroic, not because they always act as heroes, but because of the heroic associations we attach to them. Time may be a nonspatial continuum, but for her it is an overlapping, transparent collage, where elements mingle in a sophisticated but primitive genetic dance. "The layers in my collages are like squeezing random moments together," she says. "The final image is independent from time but comprised of it."

Thoughts of Scale

Neimanas uses Photoshop as her basic image creation tool, but admits to knowing little about computers and prefers not to spend her creative time learning new software. She draws with a pencil as well, and when computer methods work for her, she uses both. Part of her artistic strategy has been learning to accept the vagaries of the machine as it responds (or does not) to her commands. Although the computer taught her democracy by equalizing visual information to fit the screen, she still cannot seem to eliminate thoughts of scale, and the little magnifier in Photoshop is just not adequate for her. Still, Photoshop has taught her the value of finding, and correctly using, artistic skills and language—and what's more, she now has an organized desktop.

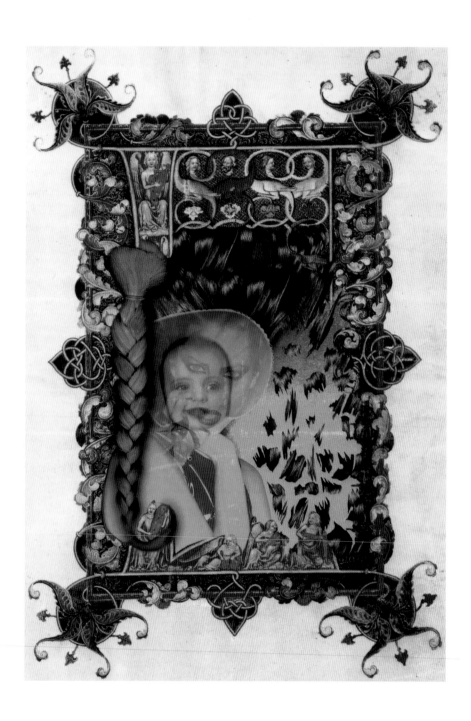

Baby Tall

18" x 12" (46 cm x 30 cm)

Ink Jet digigraph

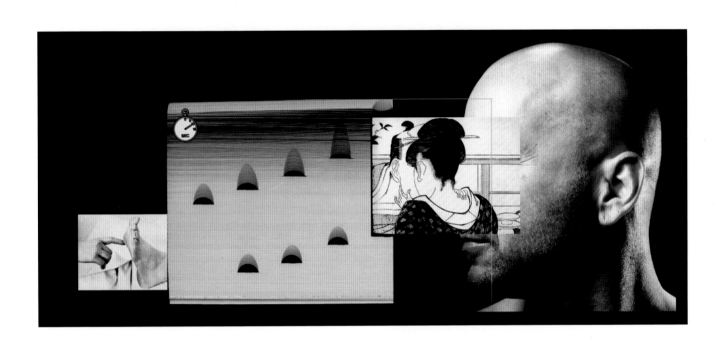

Seconds

17 7/8" x 40"
(45 cm x 102 cm)
Ink Jet digigraph

Building

16 5/8" x 11 1/2" (42.5 cm x 29 cm)

Ink Jet digigraph

Natural Target

28" x 24" (71 cm x 61 cm)

Ink Jet digigraph

the living object

Maggie Taylor

background and influences

Maggie Taylor became interested in photography while watching friends at Yale using a darkroom in her dormitory. Borrowing a camera from her father, she soon learned how to make very basic prints. After wandering around New Haven for a few months photographing odd objects in people's yards, she signed up for a photography class. For the next two years she took courses in photography and photo history, working in the darkroom almost every day.

During her graduate work at the University of Florida, she became frustrated with the very traditional color photographs she had been making and began to experiment with assembling collages and rephotographing them. This gradually led to setting up still life scenes in her yard and photographing them under natural light. These often simple but powerfully evocative objects worked to create mystical tableaus that allowed the viewer to become part of the creative/interpretive process. Several years ago she began to explore the computer as an art-making tool, and continues to create both straight color photographs and digital images.

Part of what Taylor loves about the way she makes images, is the fact that she can work at home, surrounded by the people and objects she loves—as well as three dogs and a cat. On a good day she can work on her art, do a little gardening, and cook a wonderful dinner. She always looks for flea markets and antique shops when traveling, to search for new subjects for her work. It is often color that entices her to select and use certain objects or backgrounds, and repeatedly it seems as though color is the spark that ignites the image.

It is not a question of what is missing in conventional photographs, but what else can be added with the computer. Taylor feels that its unlimited ability to change scale in the images allows her to use a wider variety of objects.

When Taylor's scanner first arrived she knew right away that she wanted to use it as a camera. Too impatient to photograph the objects first and then print them and scan the prints into the computer, she began to place her little objects and backgrounds directly on the glass, scanning them directly into digital form. "The strange light reflecting onto things from the scanner, the limited depth of field, and the painterly quality of the finished IRIS prints all intrigued me."

Taylor scans dolls, insects, pages from books, and backgrounds that she makes with paints and pastels. Anything that will fit on the scanner, top up or down, is worth trying. Some items scan better with black or white velvet behind them. Assembling the collage-like image in the computer over a period of days using Adobe Photoshop, she will make a series of small proof prints while she is working. The real challenge, she says, is to know when an image is finished.

When Taylor has completed an image she sends the digital image files for printing on an IRIS printer. Through a series of proofs and a dialogue with the person making the prints, she is able to ensure that the final print comes as close as possible to the image she has on the computer monitor.

Factual Memory and Fictional Daydream

Most of Taylor's computer images begin as a collection of individual objects and backgrounds scanned directly into the computer. Rather than work with a definite theme or philosophical construct, she prefers to work intuitively with the objects themselves. Her studio has drawers and shelves filled with all kinds of objects and pieces of text, and while the images suggest narratives, they allow the viewer to respond on a more individual basis. In fact, she wants the viewer to experience a convergence of factual memory and fictional daydream similar to her own internal dialogue in creating the work. "There are as many different interpretations," she says, "as there are viewers."

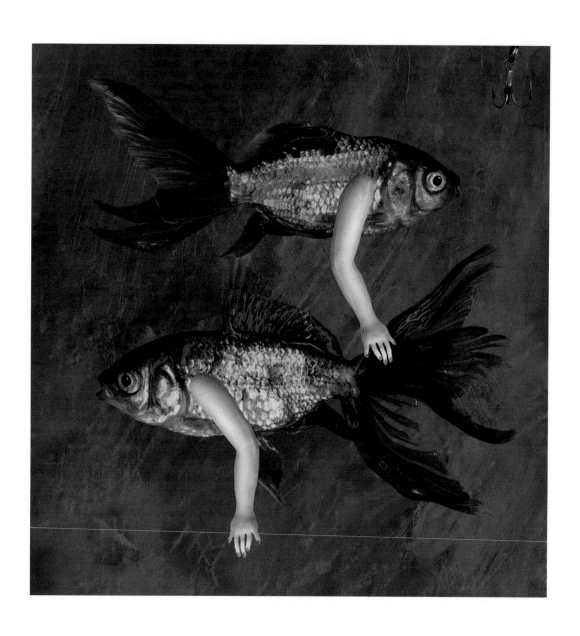

Poor Jud

20" x 16" (51 cm x 41 cm)
IRIS Ink Jet print

Easter Sunday

14" x 14" (36 cm x 36 cm)
IRIS Ink Jet print

Two Sisters

16" x 20" (41 cm x 51 cm)
IRIS Ink Jet print

Butterfly Hunter

14" x 14" (36 cm x 36 cm)
IRIS Ink Jet print

GALLERY OF ARTISTS

Altered Identities #22
Alida Fish

As mature image-makers, the photographers in our Gallery of Artists have explored a variety of photographic techniques and aesthetic directions. Included is a range of work that opens new and dynamic possibilities in the portion of the photo world we've chosen to share.

Alida Fish's *Pygmalion* series explores the metamorphosis that takes place between flesh and the living stone of her creations, while the viewer waits for the final transformation to take place. Somewhat similarly, Patricia Germani's potent, hand-colored platinum prints explore mythic themes that suggest the power of the god/goddess within us.

Grains
Eva Heyd

Untitled
Hips and Vertebrae Series
Dan McCormack

Image No. III
Fragmentary Recollections Series
Will and Lisa Oda

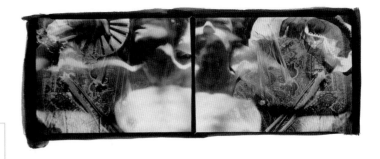

Eastern Light
Patricia Germani

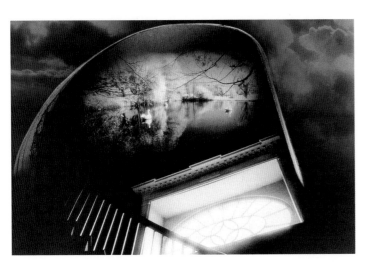

The Lake Isle of Iinnisfree
Kathryn Hunter

Dan McCormack has been photographing the nude for over thirty years. The work represented in this series uses the model in direct contact with pieces of 20" by 24" (51 cm by 61 cm) silver chloride paper to create luminous, almost abstract photograms.

Joy Taylor's subversion of reality reveals the image within the image, as two-dimensional figures are transplanted to a three-dimensional world where scale shifts, and the figures make the natural world seem unreal. Using digital media to extend her black and white infrared images, Kathryn Hunter's composites also offer an entry to a world that blurs the lines between reality and fantasy.

Eva Heyd's work on photographic linen has been stretched over three-dimensional plaster or fiberglass forms to amplify the play of light and movement, whereas Will and Lisa Oda's collaborative efforts reward us with delicately colored platinum prints alive with opalescent and visually tactile objects. Each of these artists has found a way to photograph the world we know and transform it into metaphoric images that open new and more profound associations.

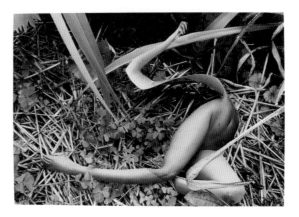

Untitled
Joy Taylor

Image No. III
(hand with shell)
from the "Fragmentary
Recollections" Series

9" x 7" (23 cm x 18 cm)

Platinum print with watercolor

**Image No. VIII
(seed pod on paper)
from the "Fragmentary
Recollections" Series**

9" x 7" (23 cm x 18 cm)
Platinum print with watercolor

Alida Fish

Altered Identities #18

20" x 16" (51 cm x 41 cm)
Digitally altered and toned
photograph

Altered Identities #22

20" x 16" (51 cm x 41 cm)
Digitally altered and
toned photograph

Dan McCormack

Untitled

Hips and Vertebrae Series

24" x 20" (61 cm x 51 cm)
Toned photogram on
Azo Paper

Untitled

Hips and Vertebrae Series

24" x 20" (61 cm x 51 cm)
Toned photogram on
Azo Paper

Patricia Germani

Eastern Light

5" x 14" (13 cm x 36 cm)
Platinum print with oil color

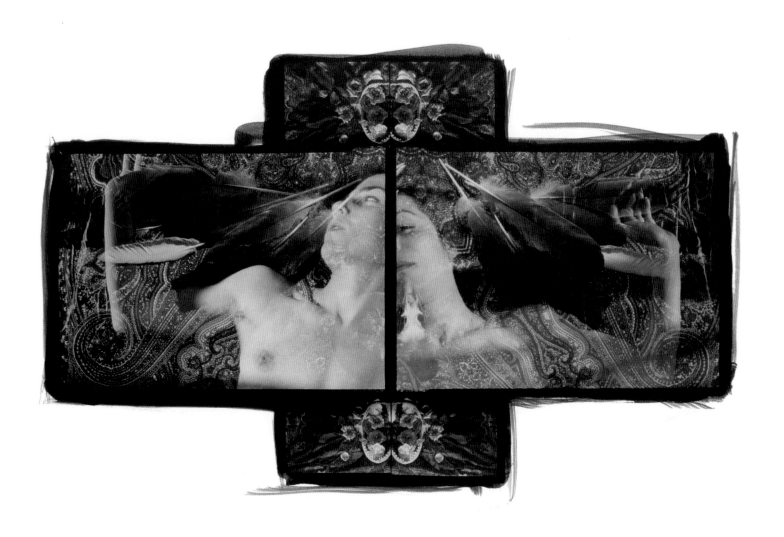

Totem

8 1/2" x 14" (22 cm x 36 cm)
Platinum palladium print

Joy Taylor

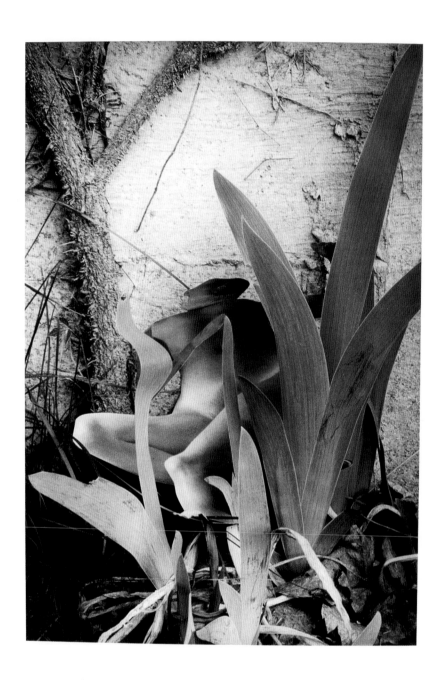

Untitled

12 3/4" x 8 3/4" (32 cm x 22 cm)
Silver gelatin print

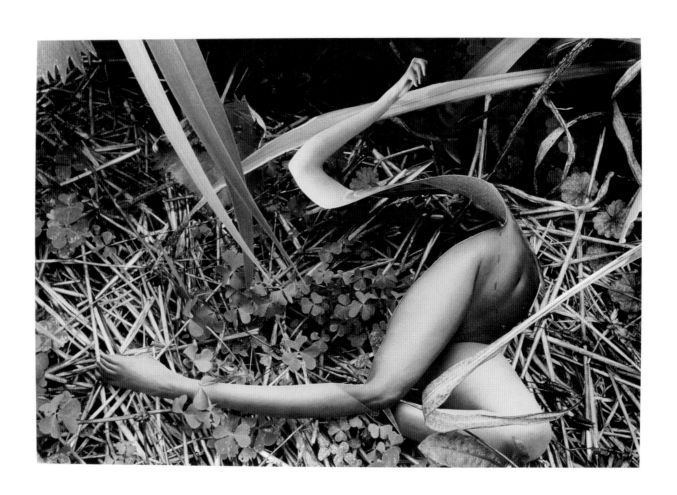

Untitled

8 3/4" x 12 3/4" (22 cm x 32 cm)
Silver gelatin print

Eva Heyd

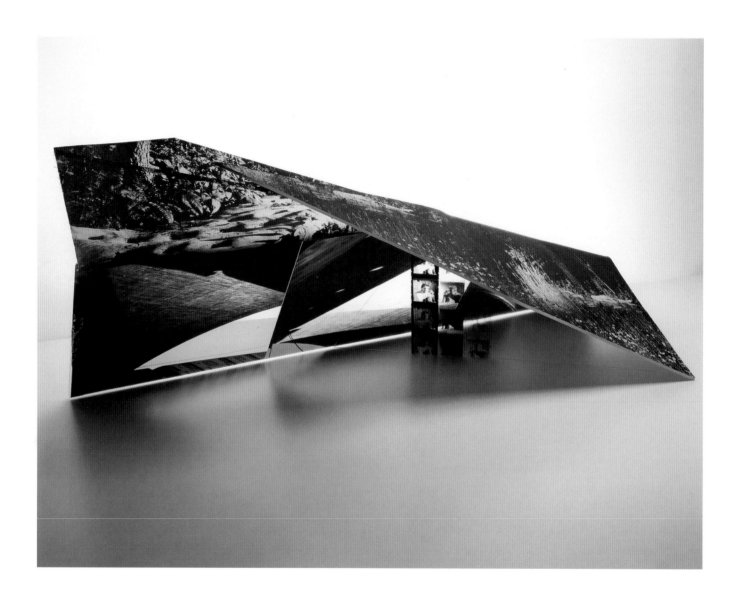

Fadeaway

60" x 19" x 30"
(152 cm x 48 cm x 76 cm)
Plexiglass, duraclears

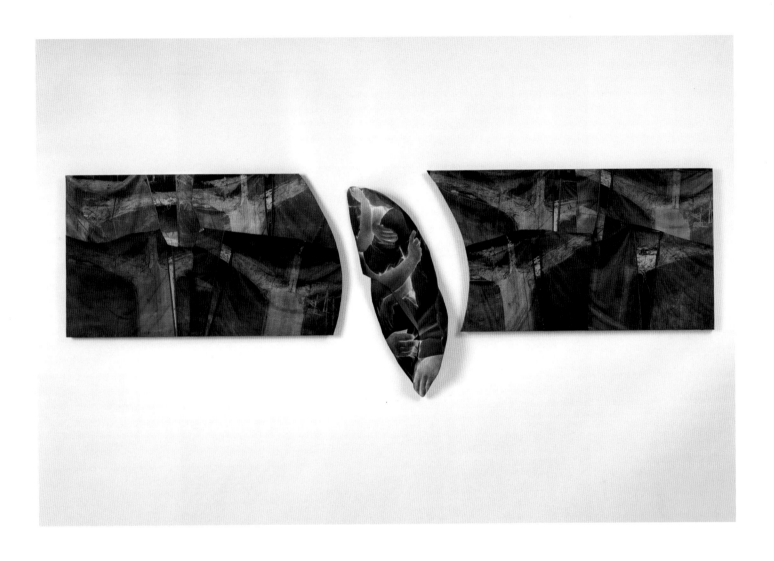

Grains

7 1/2" x 21" (19 cm x 53 cm)
Photolinen, plaster

Kathryn Hunter

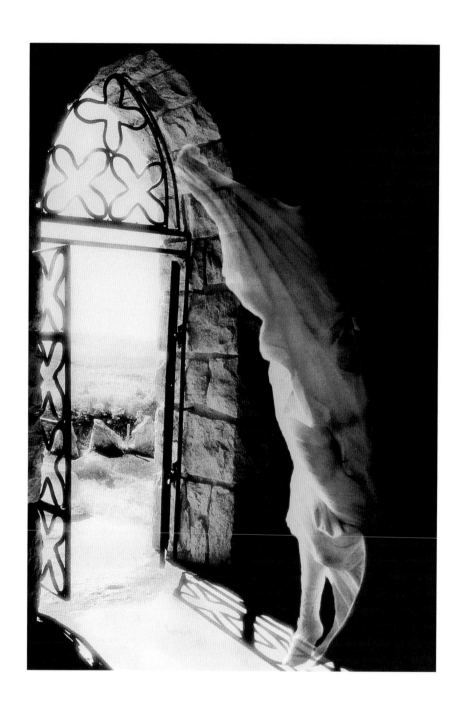

Escape

18" x 12" (46 cm x 30 cm)
Digital composite from
black and white infrared

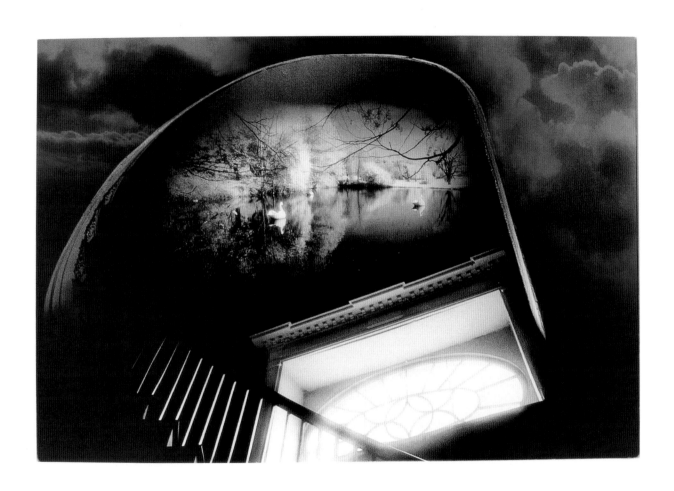

The Lake Isle of Innsfree

12" x 18" (30 cm x 46 cm)
Digital composite from
black and white infrared

GLOSSARY

collodion A solution of gun cotton (cellulose nitrate) and ether initially used by Frederick Scott Archer in 1851 to help bind photographic emulsion to glass in the development of the wet plate process.

contact printing process Any process that requires a negative to be printed in contact (emulsion to emulsion) with the light-sensitive medium. This is usually the case with less sensitive, non-silver photographic processes where enlarging an image would be virtually impossible. The result is an image that is the same size as the negative being printed. For example, a 16" by 20" (41 cm by 51 cm) print would require a 16" x 20" (41 cm by 51 cm) negative.

continuous tone Designates an image in which a full range of tones from light to dark exists. This can either be a positive or negative image.

cyanotype Developed by Sir John Hershall in 1842, this relatively slow, contact printing process uses less sensitive iron salts that result in a telling blue or "cyan" color.

densitometer A device that measures the relative density of negatives or prints, which helps to visualize the resulting range of tones in the final print.

enlarged negative A negative made to the size of the final print for contact printing. This can be made either directly in a copy camera or in the darkroom from a smaller negative.

fine-grain positive A continuous tone film material that, like conventional photographic paper, can be used in the darkroom under a safelight. It yields continuous tone transparencies.

gelatin A colloid often used as a sizing for paper in preparation for applying certain photographic emulsions.

gum bichromate Patented by Alphonse Louis Poitevin in 1855, this process is based upon the discovery (made by Henry Fox Talbot in 1839) that potassium dichromate darkens upon exposure to light. By combining potassium dichromate or the more sensitive ammonium dichromate with a colloid (gum arabic) and a water soluble pigment, a light-sensitive emulsion is formed that can be brushed onto a paper substrate, exposed, and developed. Where light strikes the emulsion, the emulsion hardens and remains. Unexposed areas do not harden, and so wash off during development, which takes place in a series of delicate water washes. This is a slow and sometimes tedious process requiring the paper to dry thoroughly between coatings.

halftone A photographic image that has been broken up into small dots, to give the illusion of continuous tone in high-contrast printing processes, such as offset lithography.

IRIS print A sophisticated ink jet print yielding very high quality prints from digital files.

Kwik print See synthetic gum bichromate.

lithography Printing process where the plate (metal or stone) is chemically treated to accept ink and repel water. The non-image plate areas repel ink and accept water.

multiple image photography Describes a number of processes where negatives are combined to create a single image, either in camera through multiple exposures, in the darkroom using a variety of printing techniques, or during printing sessions using non-silver techniques where images can be layered one over the other.

non-silver process A more or less generic term used to describe any of the nineteenth century, hand-applied emulsions using light-sensitive salts based in metals other than silver.

oil print Introduced by G. E. H. Rawlins in 1904, an oil print uses oil-based inks on paper that has been coated, exposed, and developed to create a "resist" for the inks.

orthochromatic Any photographic emulsion not sensitive to the red portion of the light spectrum. This makes it possible to use the material in a darkroom under a red or sometimes amber safelight.

Ortho litho film An orthochromatic high contrast film material that can be enlarged on in the darkroom like conventional photographic paper. Developed in diluted print developer, it yields continuous tone transparencies.

paper negatives Light-sensitive photographic paper can be used instead of film to create negatives as well as positives. This can be done by placing the photo paper in the back of a view camera or pinhole camera, or by contact-printing a positive image onto a sheet of photo paper to reverse the tonalities and create a negative image.

photo emulsion A light-sensitive coating on any substrate (film or paper are most often used) to create photographic images.

photogram A stencil-like image created by placing objects directly onto a photographic emulsion and exposing them to light, producing a negative image.

photogravure A nineteenth-century tone-for-tone reproduction process in which a sensitized, exposed, and etched copper plate is evenly inked, then wiped clean to remove the ink from the surface of the plate while leaving ink in the etched crevasses. A uniformly dampened paper is then laid over the metal plate and ink from the plate is forced from the grooves onto the paper by the pressure of the press.

Photoshop A premier digital program produced by Adobe, which has become the industry standard for manipulating photographic images.

pinhole negative A negative created in a pinhole camera. A camera is essentially defined by four elements—a light-tight box, an aperture (in this case a pinhole) to let light into the camera, a shutter to control the duration of time light enters the camera (perhaps a piece of black tape or a cardboard flap), and a film plane (the flat surface where the film will be in focus). The pinhole aperture is so small that the depth of field makes focusing unnecessary. Pinhole cameras can be made any size, and produce negatives as large as the film materials used.

platinum/palladium print Ferric Oxalate (the sensitizer) is the substance used to bond with the platinum or palladium salts and form the initial image. After exposure, a faint provisional image is formed. Even if there is no platinum or palladium salts in the emulsion, this provisional image, created by the exposed ferric oxalate, would exist. When the printed image is placed in the developer, the platinum or palladium that is in contact with the ferrous salt is reduced to metallic platinum or palladium, and at that point becomes visible. The ferrous (iron) salts are then removed by soaking the print in several successive solutions of a weak acid. The resulting image is at this point composed wholly of metallic platinum or palladium. The print is then washed and dried.

Polaroid transfer process The mechanical transfer of a Polaroid image from its original base to a different support material. After exposure and partial development, the Polaroid material is peeled apart, and the negative placed face down on the transfer sheet (most often a fine art paper). A roller or squeegee is used to bond the negative to the new paper substrate. After several minutes the negative is peeled back to reveal the transferred image.

silver gelatin print A print on a modern-day photographic paper produced commercially, using a silver chloride or silver bromide salt in a gelatin emulsion. These papers come in a variety of surfaces and contrasts, including those in which the contrast can be controlled through the use of filters.

solarization Initially used to describe partial tone reversal resulting from overexposure in early printing processes, the term is now often used interchangeably with the sabattier process, a similar effect caused by exposure to light during the developing process.

synthetic gum bichromate In this process, colors come prepared and ready for coating, usually on special plastic sheets. These materials can be buffed onto the sheets quickly, dry almost immediately, and are exposed and developed in plain water. The advantage of this process is the speed with which multiple coatings can be accomplished. Also called a Kwik print.

tintypes A collodion wet-plate emulsion coated onto black enameled (japanned) tin to form a positive image directly upon development.

type c print Generic name for conventional color printing papers made for use with color negatives. The emulsions within this paper contain color couplers that form dyes when the exposed silver emulsion is developed. Once the silver is bleached out of the paper, only the dyes remain.

Van Dyke Often included with the non-silver processes because of its similarity in terms of technique, this process is similar to the cyanotype, with the primary difference being the light sensitive metal salt. The Vandyke (brown print) uses a more expensive silver salt (silver nitrate) and an iron (ferric ammonium citrate), which accounts for the difference in print color.

wet plate process Developed in 1851 by Frederick Scott Archer, this process uses glass plates coated with a salted collodion, which is then dipped into a solution of silver nitrate to sensitize the plate. As collodion is impervious to water when dry, the plate must be sensitized, loaded into the camera, exposed, and developed while still wet—thus the name "wet plate process."

DIRECTORY OF ARTISTS

Morel Derfler
7495 Prospect Road
Cupertino, CA 95014

Francois Deschamps
120 Hasbrouck Road
New Paltz, NY 12561

Dan Estabrook
344 Grand Street, Front
Brooklyn, NY 11211

Alida Fish
1816 Millers Road
Wilmington, DE 19810

Patricia Germani
29 Boniello Drive
Mahopac, NY 10541

Eva Heyd
84-28 63rd Road
Middle Village, NY 11379

Kathryn Hunter
122 Sycamore Drive
New Windsor, NY 12553

Dan McCormack
13 Beehive Road
Accord, NY 12404

Thomas Mezzanotte
955 Connecticut Ave.
Bridgeport, CT 06607

Luiz Guimarães Monforte
Rua Aureliano Coutinho 222, Apt. 31
01224-020 São Paulo, Brazil

Rachel Murray
251 Bocana Street
San Francisco, CA 94110

Judy Natal
125 South Racine
Studio #3F
Chicago, IL 60607

Joyce Neimanas
1801 West Wabansia
Chicago, IL 60622

Bea Nettles
406 West Iowa
Urbana, IL 61801

Will and Lisa Oda
2339 40th Avenue
San Francisco, CA 94116

Olivia Parker
229 Summer Street
Manchester, MA 01944

Tim Pershing
19752 Grand View Drive
Topanga, CA 90290

John Reuter
48 Gautier Ave.
Jersey City, NJ 07306

Ernestine Ruben
644 Spretty Brook Road
Princeton, NJ 08540

E. E. Smith
497 Pacific St., 4A
Brooklyn, NY 11217

Keiichi Tahara
Baudoin Lebon, gallérie
38 Rue Sainte Croix de la Bretonnerie
75004, Paris

Joy Taylor
RD#1 Box 95
Red Hook, NY 12571

Maggie Taylor
5701 SW 17th Drive
Gainesville, FL 32608

Jerry Uelsmann
5701 SW 17th Drive
Gainesville, FL 32608

INDEX

ABOUT THE AUTHORS

James Luciana received his Master of Fine Arts degree from Arizona State University in 1976, and is currently an associate professor of art at Marist College in Poughkeepsie, New York. He also teaches courses and workshops in non-silver/alternative processes and digital imaging at the International Center of Photography in New York. His work has appeared in numerous solo and group exhibitions, and most recently has been added to the collections of the European Museum of Photography and the Bibliothèque Nationale in Paris.

Pair Only
7" x 5" (18 cm x 13 cm)
James Luciana

Judith Watts is a freelance photographer specializing in architecture and interiors. Her photography has been published in *House Beautiful, Colonial Homes, Country Home, Better Homes and Gardens, Home,* and many other national publications. She recently completed her first book of photography, *Inside Architecture: Interiors by Architects.* Watts received a Bachelor of Arts in art history from Smith College and a Master of Fine Arts from the Rochester Institute of Technology, where she studied with Bea Nettles, a pioneer of alternative photographic processes.

Untitled
13" x 8 ³/₄" (33 cm x 22 cm)
Judith Watts